Historic England

Leicester

Stephen Butt

AMBERLEY

Acknowledgments

In many instances, I have found valuable information on a location from the Transactions of the Leicestershire Archaeological and Historical Society. The paper by the late Dr Paul Courtney on the topographical evolution of medieval Anstey (Vol. 77, 2003) is an example.

Few buildings are exempt from change, and their more recent history is recorded in heritage and archaeological assessments accompanying planning applications or in the local plans of district councils. I have drawn on both these rich sources of information.

I must also acknowledge the local historians who document the heritage of their village or neighbourhood in community and weekly regional newspapers, which are another invaluable source of information.

First published 2018

Amberley Publishing
The Hill, Stroud, Gloucestershire, GL5 4EP
www.amberley-books.com

Copyright © Stephen Butt, 2018

The right of Stephen Butt to be identified as the Author of this work has been asserted in accordance with the Copyright, Designs and Patents Act 1988.

ISBN 978 1 4456 8362 1 (print)
ISBN 978 1 4456 8363 8 (ebook)

British Library Cataloguing in Publication Data.
A catalogue record for this book is available from the British Library.

Origination by Amberley Publishing.
Printed in Great Britain.

Contents

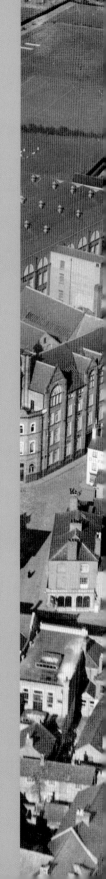

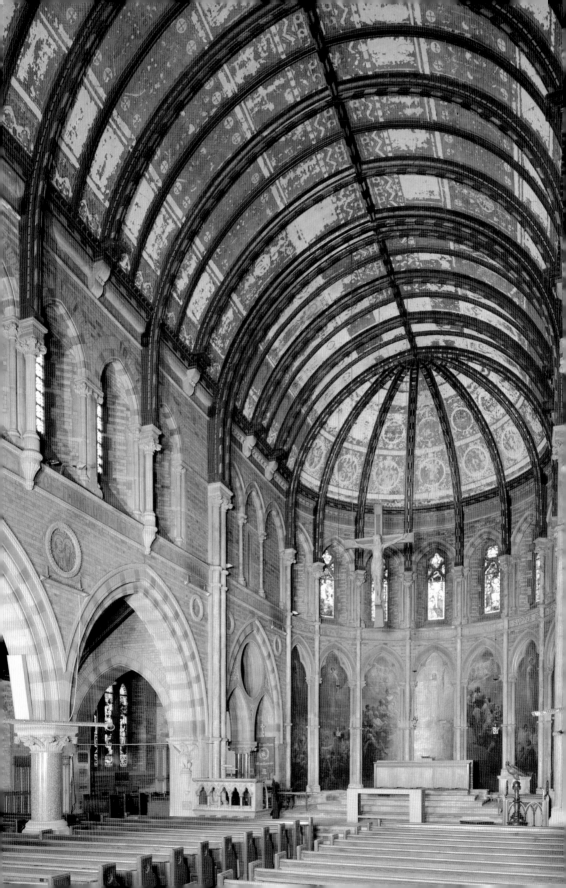

Introduction

The Historic England archive is an assembly of distinct photographic collections from the earliest days of photography to the present day. Browsing this collection of over twelve million items, the different techniques of the contributors and the reasons why certain photographs were taken become evident.

In 1887, the respected photographer Henry Bedford Lemere was commissioned by Mrs Percy Herrick to provide a set of images of Beaumanor Hall near Loughborough. The result is a glossy and impressive collection showing the building at its best, with, for instance, the dining room prepared for a banquet. This is still the form of imagery used in today's sales brochures for country houses.

Lemere's company was very active in Leicester in the late nineteenth century recording the new buildings springing up in the town. Many of these images were commissioned by the architects, such as Arthur Wakerley, so are architectural in their composition. Clearly some of the angles and views were dictated by the architects rather than by the photographer.

When cameras became more portable and film more adaptable to conditions, a more natural style of photography evolved. People were no longer excluded, so the images gained a sense of immediacy. Photographers were later to focus on people, often using them to provide context. An early example in Leicester is a candid shot of the Prince of Wales, later Edward VII, and his son, the Duke of York, later George V, in a coach outside Leicester railway station on 20 June 1896.

The British postcard industry began in 1894 when the Royal Mail first accepted picture postcards. This thriving industry provided work for many photographers including those working locally like the village pharmacist in Kibworth, and others who travelled the country. Postcards, because of their dimensions, also influenced, to an extent, the composition of a scene, compared to the square lantern slides of the past. Some collections simply represent the personal interests of the photographer, such as the railway images of the Revd H. D. E Rokeby of Thetford.

The importance of the Historic England archive is that it protects many unique collections from destruction, either through neglect or lack of understanding. Plumber turned professional photographer Henry Taunt, for instance, left over 53,000 glass slides from a career spanning more than half a century. After his death in 1922, most were either smashed or used to build a greenhouse.

The City of Leicester

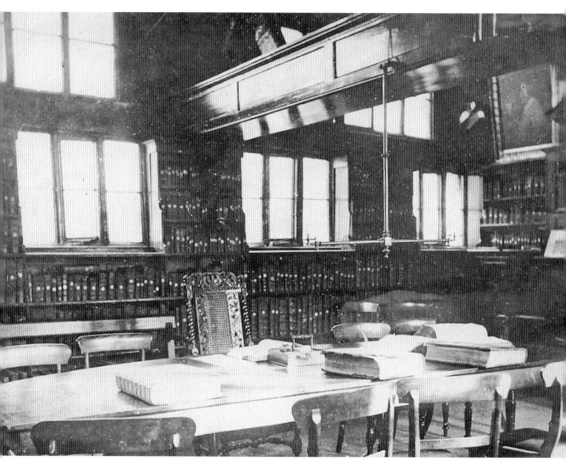

Above: The Town Library, the Guildhall, Leicester
The Great Hall was built around 1390 for the Guild of Corpus Christi. The town library moved here in 1632 from St Martin's Church (now Leicester Cathedral). Books include the *Codex Leicestrensis*, an important manuscript of the New Testament in Greek from the 1400s, and a Latin grammar of 1592 signed by playwright Ben Johnson.

Opposite: Joseph Johnson's Department Store, Belvoir Street, Leicester
Built in 1880 by the renowned Arts and Crafts architect Isaac Barradale of Leicester, over time this dignified building brought together Joseph Johnson's businesses under one roof. This photograph was taken in 1885. The store was later owned by Fenwicks until March 2017. Part of the building is now Grade II listed. (Historic England Archive)

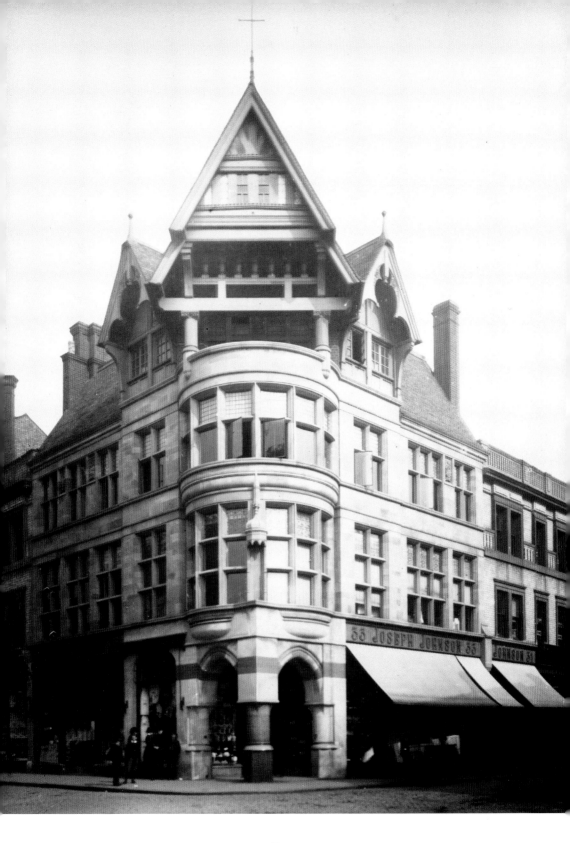

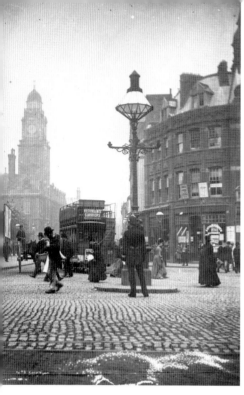

Left: Horsefair Street, Leicester
Viewed from the junction of Gallowtree Gate, Granby Street and Halford Street, this image is looking south-west along Horsefair Street in around 1900. The Town Hall, Town Hall Square and Bowling Green Street are on the left. The former United Counties Bank on the corner of Bowling Green Street is still standing. (Historic England Archive)

Below: The Town Hall, Leicester
Leicester's Town Hall from Horsefair Street. This photograph is from a collection of images of Leicester taken in 1885 by the London-based Bedford Lemere & Co. The company pioneered the photography of new buildings and was often commissioned by architects for portfolios. Leicester's Town Hall was built in 1874–76 to a design by Francis Hames. (Historic England Archive)

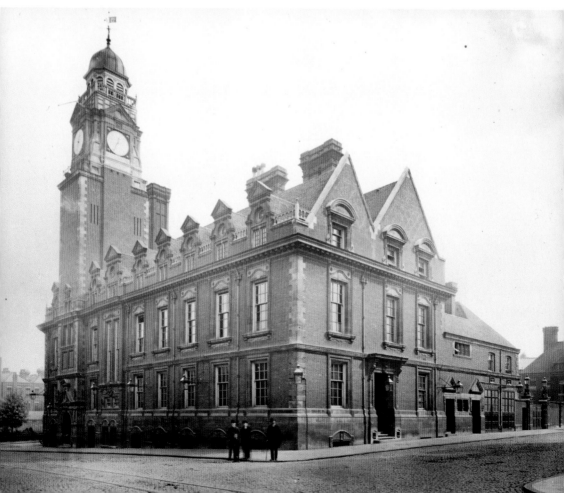

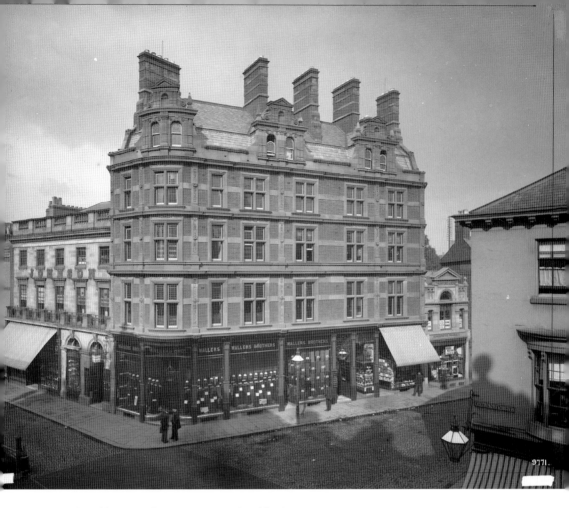

Imperial Buildings, Gallowtree Gate and Halford Street
Designed by Robert Johnson Goodacre (1826–1904) of Friar Lane, Leicester, this impressive building on the corner of Gallowtree Gate and Halford Street is still standing. It is home to several businesses and retail premises. Goodacre was a descendant of John Johnson, the founder of Leicester's Consanguinitarium, and was responsible for its rebuilding in Earl Howe Street. (Historic England Archive)

Woolworths, Gallowtree Gate
As recently as the 1960s, F. W. Woolworth's stores were still described as 'bazaars' in street directories. Woolworths rebuilt this store in the 1960s as an assurance that they were not leaving the city for their new superstore in Oadby. After Woolworths moved to Leicester's Haymarket Shopping Centre, BHS (British Home Stores) took over the premises until their demise in 2016. (Historic England Archive)

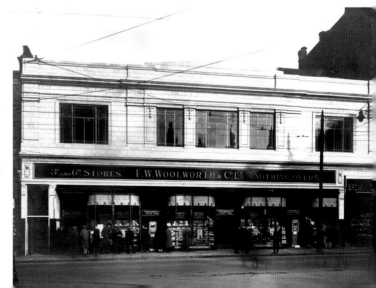

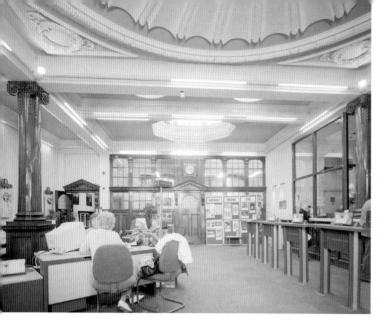

The Co-operative Bank, Nos 5–9 Hotel Street
The opulence of the banking hall of the former Co-operative Bank in 1997 seems out of keeping with the organisation's working-class roots in a city that has historic connections with the co-operative movement. The reason is that the bank was built for the Prudential Insurance Co., which was keen to demonstrate wealth and prosperity. (© Crown copyright. Historic England Archive)

London Road, Leicester
This terrace of shops on the corner of London Road and Highfield Street was still being built when this photograph was taken in 1889. Nos 122–128 London Road and Nos 2–6 Highfield Street are in the foreground with building work continuing at Nos 118–120 London Road. The buildings were designed by the Leicester architect Arthur Wakerley. (Historic England Archive)

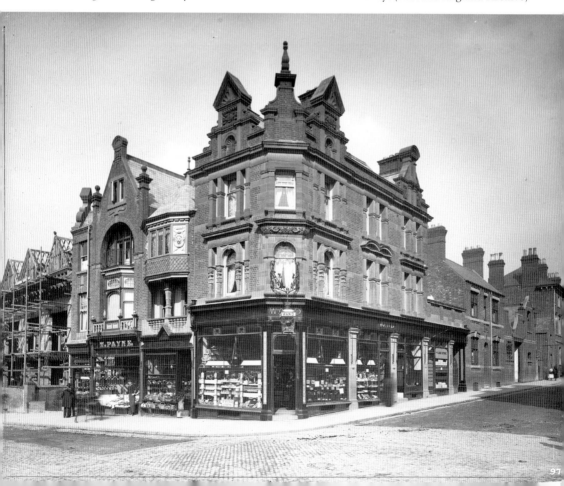

New Walk

Leicester's sedate and tranquil New Walk was laid out in 1785 roughly along the line of the Via Devana Roman road. Development along the route was piecemeal over more than a century. These houses, on the corner of New Walk and Salisbury Avenue, were designed by Stockdale Harrison, and are now part of Leicester University. The photograph was taken in 1890. (Historic England Archive)

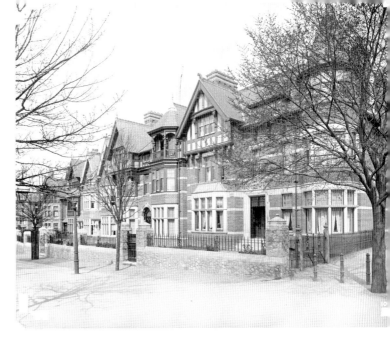

The Congregational Chapel, Humberstone Road

Somewhat austere and modernist for its time, the Congregational Chapel, or Union Church, was designed by Arthur Wakerley in 1887. It could seat 750 worshippers. The church rooms, including a stage and balcony, were in adjacent Newby Street. The church and Newby Street were demolished to make way for the Kingfisher Avenue estate. (Historic England Archive)

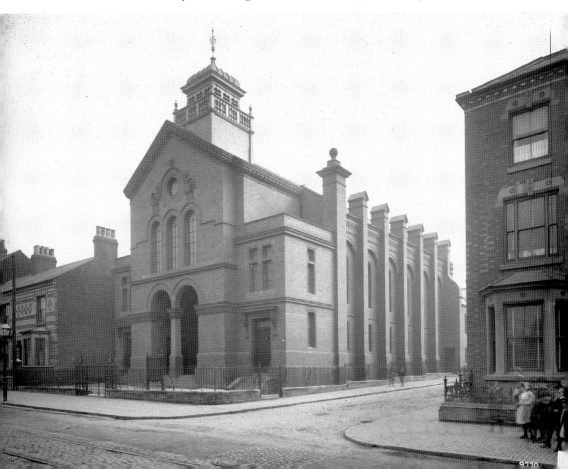

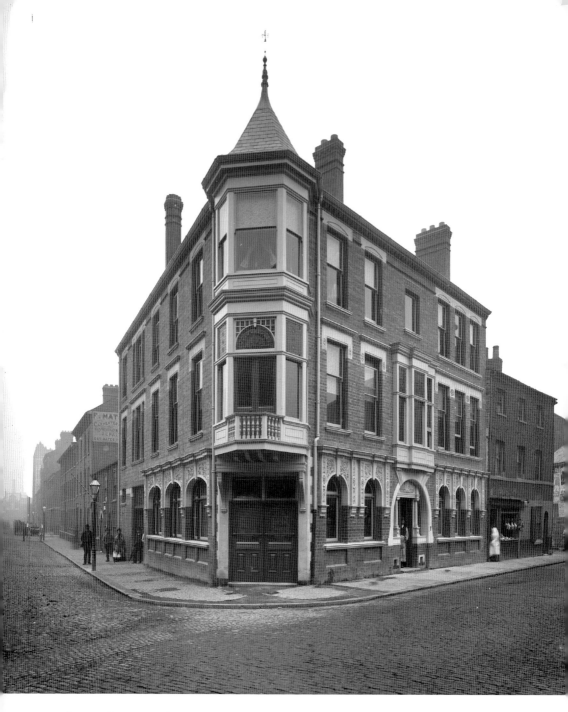

Above and opposite above: The Queen's Hotel, No. 14 Rutland Street
A view of the Queen's Hotel, at the junction of Rutland Street and Charles Street, Leicester. It was designed by Arthur Wakerley, for whom this photograph was taken in 1889. The photograph of the modestly appointed Commercial Room was taken for W. H. Lowe, possibly William Henry Lowe, who was treasurer of the Leicester Trades Council at the time, as this seems, from available accounts, to have been a more working-class establishment. (Historic England Archive)

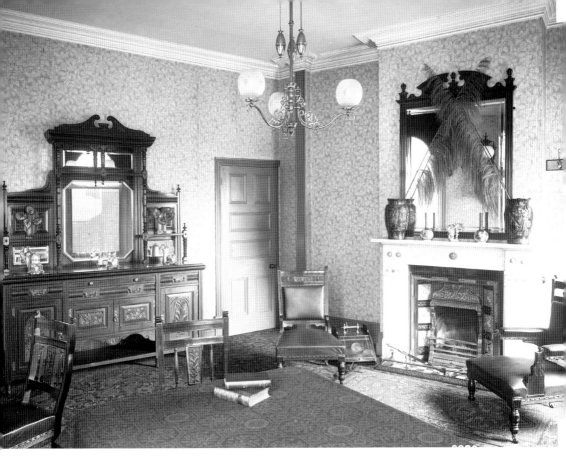

Right and overleaf: The Liberal Club, Bishop Street
The Liberal Club was designed by Edward Burgess in 1888 in the shadow of the Town Hall, which was then the seat of political power in Leicester. It was important that the Liberals were in easy reach of where decisions were being taken. The club was also the Gladstone Buildings, and a portrait bust of Gladstone can still be seen in the lobby. The sculptor was George Saul RA. The photographs of the interior show the Reading Room and the Smoking Room in 1889. (Historic England Archive)

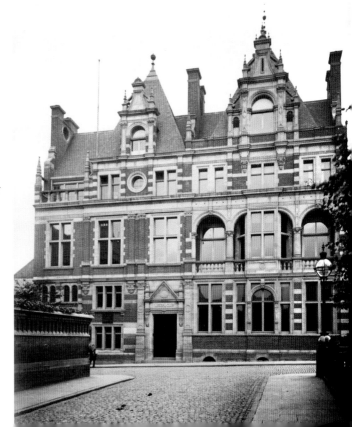

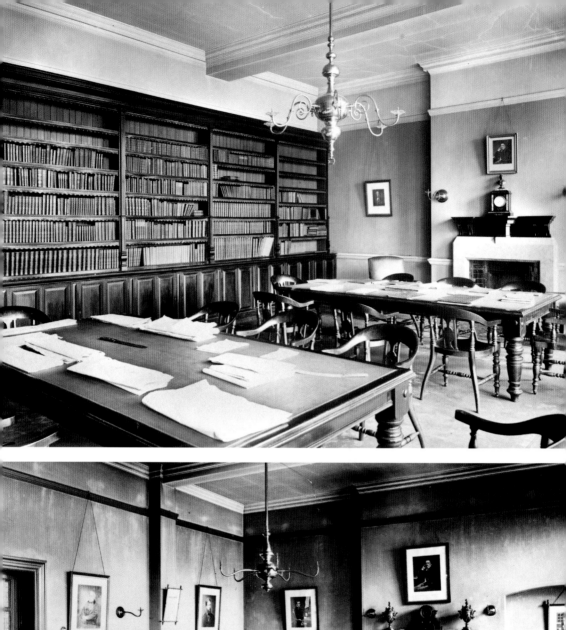
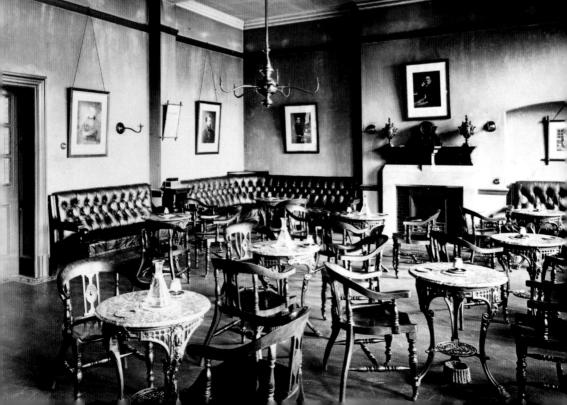

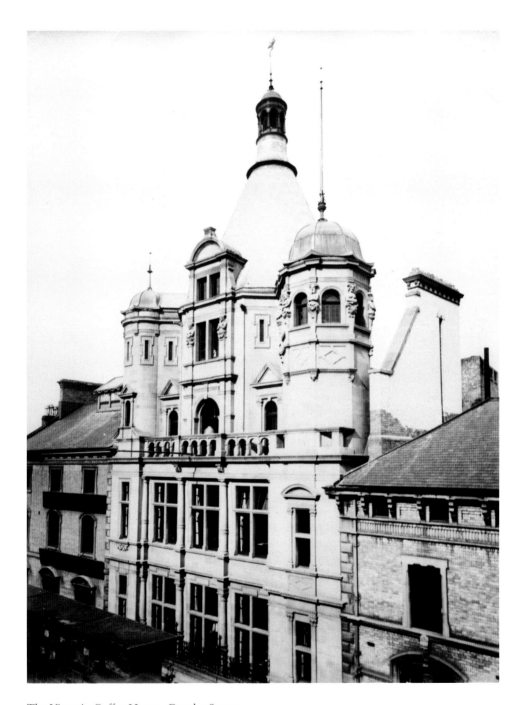

The Victoria Coffee House, Granby Street
The impressive Victoria Coffee House was designed by Edward Burgess, one of six premises
he designed for the Leicester Coffee and Cocoa House Co. It was opened by the Duchess of
Rutland in December 1888. It is built of Santon stone from the Isle of Man with walls of
polished Aberdeen granite and staircases lined with glazed tiles. (Historic England Archive)

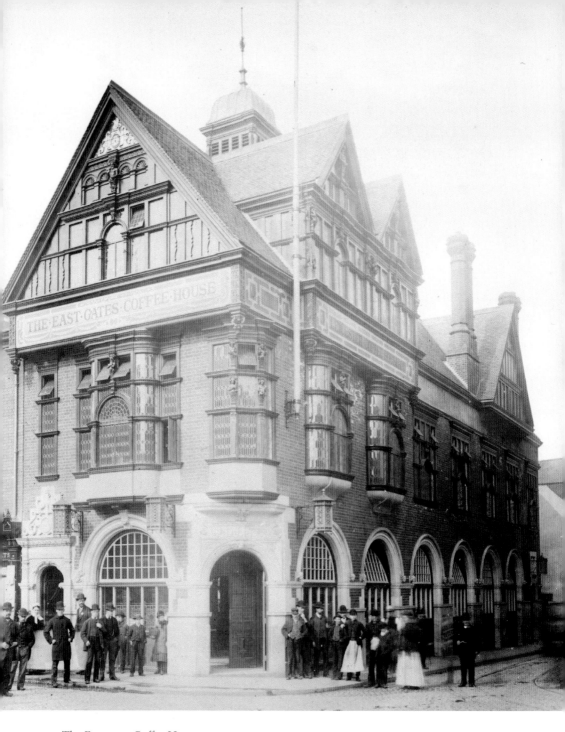

The Eastgates Coffee House
On the corner of Churchgate and designed by Edward Burgess in an Arts and Crafts style described as the 'domestic style of the fifteenth century', this is still a dominant architectural presence in the heart of Leicester, overlooking the clock tower, serving as a retail clothing store. The photograph by Henry Bedford Lemere is dated 16 September 1885. (Historic England Archive)

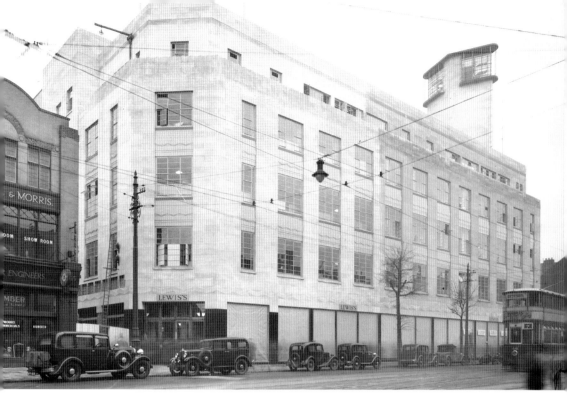

Above, below and overleaf: Lewis's Department Store, Humberstone Gate
Five images of the Lewis's store photographed by Herbert Leo Felton in 1936, the year it opened. In keeping with owner David Lewis's concepts, the interior of the store presented an image of luxury, as these photographs of the ladies' wear department, cosmetics section, restaurant and children's play area indicate. The store closed in 1991 and was demolished apart from the tower. (Historic England Archive)

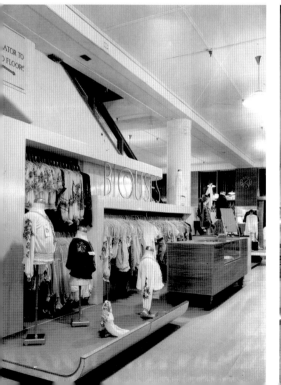

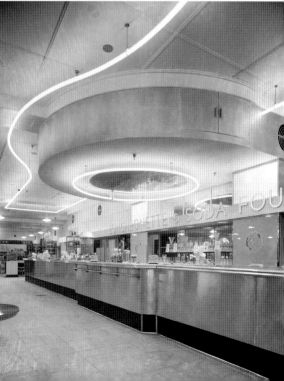

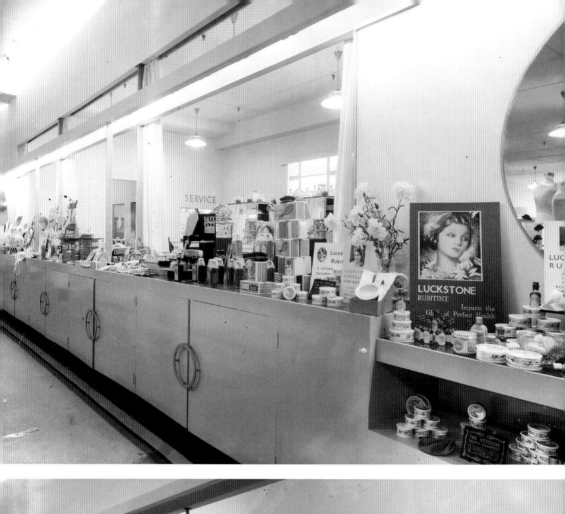

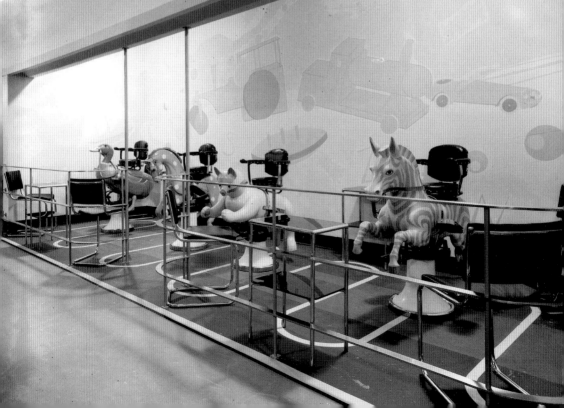

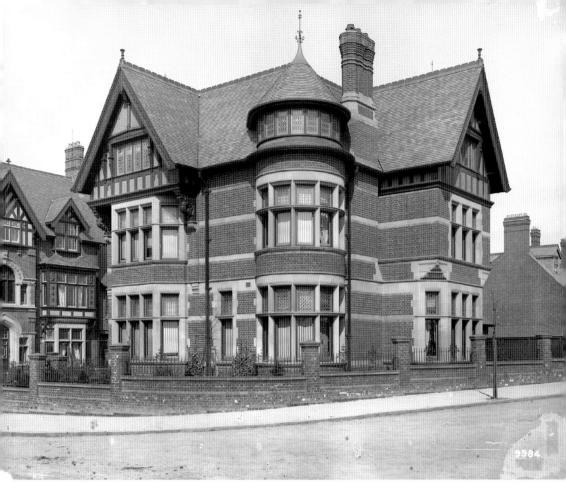

Above: Glen Avon, London Road
Glen Avon was designed by the architects Stockdale Harrison & Sons in 1890 to provide a landmark building at this important junction. It was later used as a car showroom, and in 1975 was converted into a branch of Lloyds Bank. In 2017 a planning application was submitted to use the building for student accommodation. (Historic England Archive)

Right and overleaf: Leicester Isolation Hospital, Groby Road Designed by local architects Blackwell and Thompson and completed in September 1900, this fine hospital consisted of separate buildings spread across a wide campus with revolutionary heating and water systems to prevent cross infection. The main building is now a restaurant and the rest of the site is a housing development. Also illustrated is one of the isolation wards and the main entrance gates and lodge. (Historic England Archive)

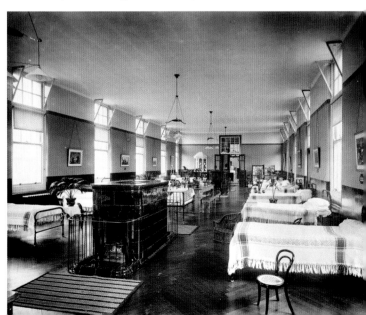

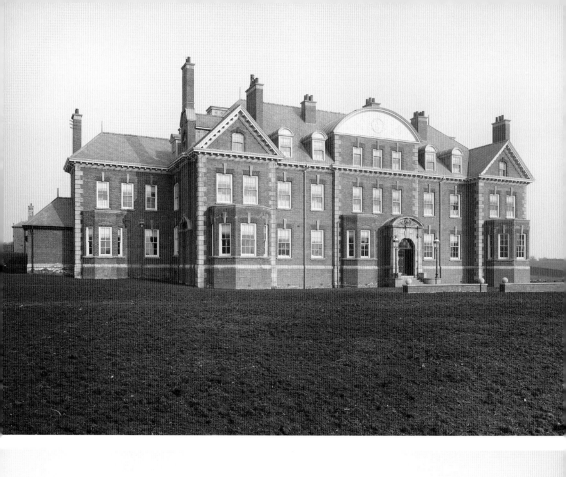

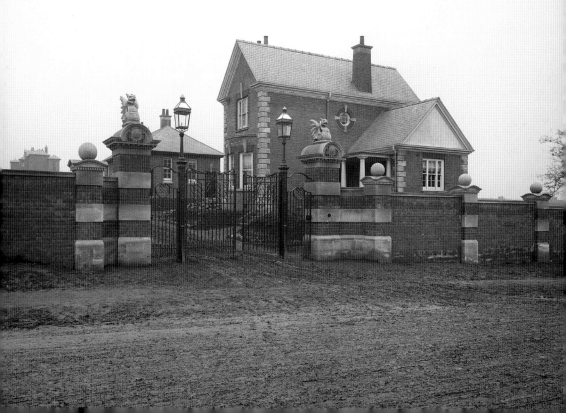

Castle Yard, Leicester
A view of the timbered gatehouse adjoining Castle House, which dates from 1445, and the Norman door of the Church of St Mary de Castro in Castle Yard. The photograph was taken on 17 September 1885, but this area at the heart of medieval Leicester has changed little in the intervening years. (Historic England Archive)

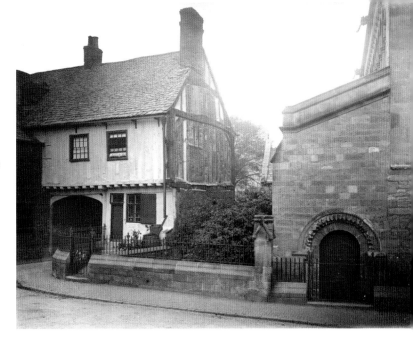

Humberstone Gate
Thomas Cook's offices in Gallowtree Gate provide the location and orientation for this photograph taken on 10 January 1907. The Midland Railway offices are on the left. The building on the corner was replaced by Montague Burton, the tailors, and is now a branch of the HSBC bank. The Haymarket Centre now occupies the northern side. (Historic England Archive)

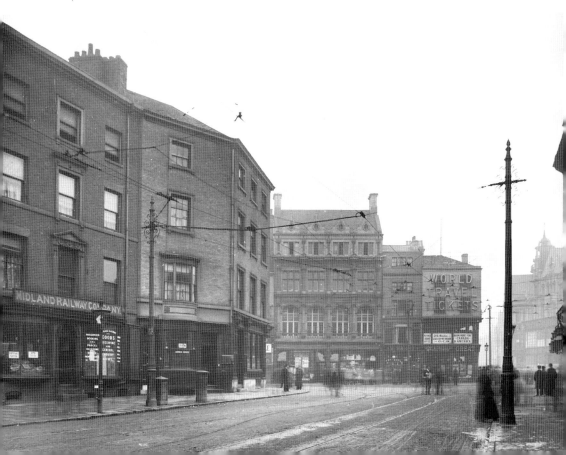

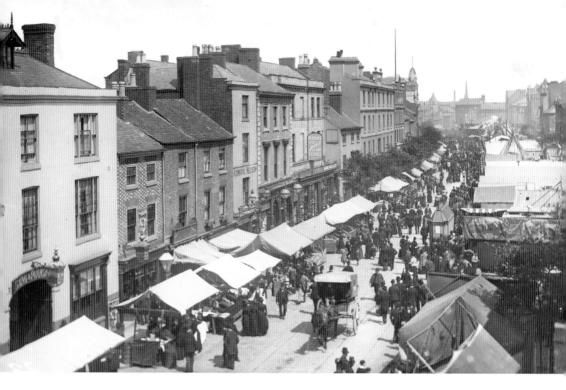

Above: Humberstone Gate
A view along Humberstone Gate in 1892 looking east. The last of the infamous Humberstone Fairs took place in 1904, but this photograph may be of the Haymarket then held every Wednesday near the weighbridge (now a private taxi office), which was erected in 1870–71. (Historic England Archive)

Below: De Montfort Hall
Leicester architect Shirley Harrison chose to design Leicester's premier concert hall in a classical style. Son of the equally famous architect Stockdale Harrison, he produced a building of simplicity and symmetry that still makes an impressive visual statement today. Constructed in 1913, the hall has accommodated classical concerts, graduation ceremonies, speech days, dances, rock concerts and wrestling in near equal numbers.

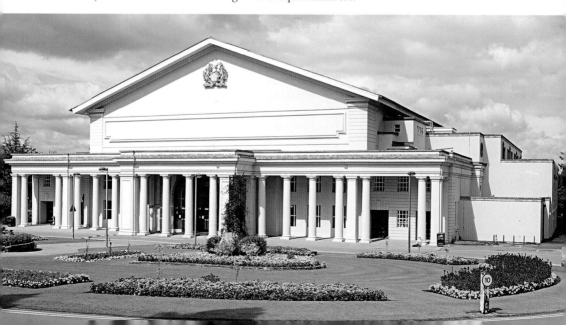

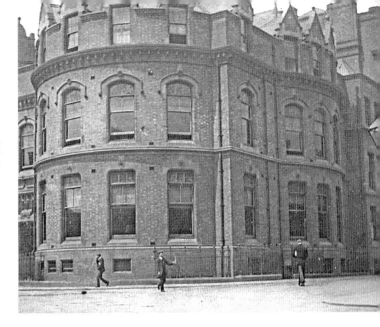

The Leicester Club, No. 9
Welford Place
Many of Victorian Leicester's
successful businessmen wanted
to join the town's country club
but its gentry membership
refused them admittance.
Undeterred, they formed their
own Leicestershire Club with
this building, completed in
1877, as their headquarters.
It has retained many original
features. This image is from a
glass lantern slide and dates to
around 1895.

The Theatre Royal, Horsefair Street
The Theatre Royal opened in January 1837, designed by William Parsons, then the county
architect. The exterior featured a Grecian pillared façade, which extended over the pavement.
The auditorium was horseshoe shaped. It ran into debt in October 1956. A financial rescue was
attempted but failed, and the theatre closed permanently in May 1957, the last production being
Trial and Error by Kenneth Horne.

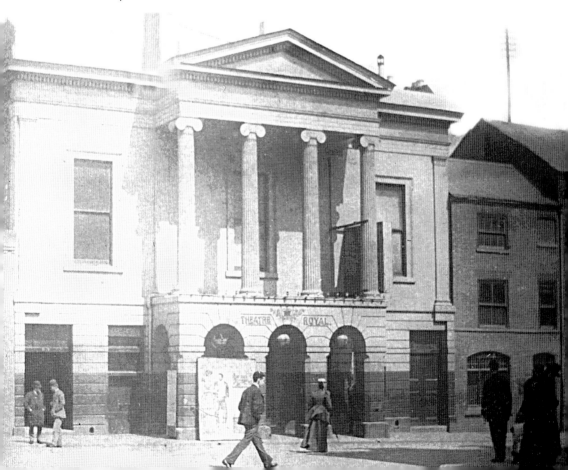

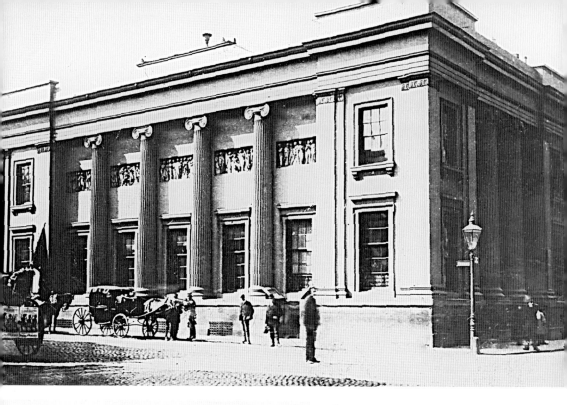

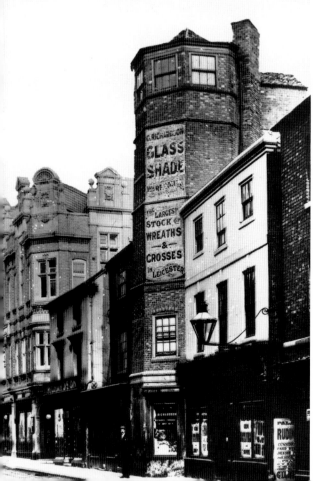

Above: General Newsroom, Belvoir Street

This imposing building opened in 1837 as a general newsroom and library, and was designed by local architect William Flint. It cost £6,000 and contained a gallery for the library, committee rooms and apartments intended to provide education and enlightenment, mainly for men. It was demolished in 1896 as part of 'street improvements'.

Left: Huntingdon's Tower, The Lord's Place, High Street

This was the last surviving remnant of a grand house built by Henry, Earl of Huntingdon, in 1569. Mary, Queen of Scots, James I and Charles I are said to have stayed here. The tower stood on the corner of New Bond Street and High Street and was demolished in 1900 when High Street was widened to accommodate trams. (Historic England Archive)

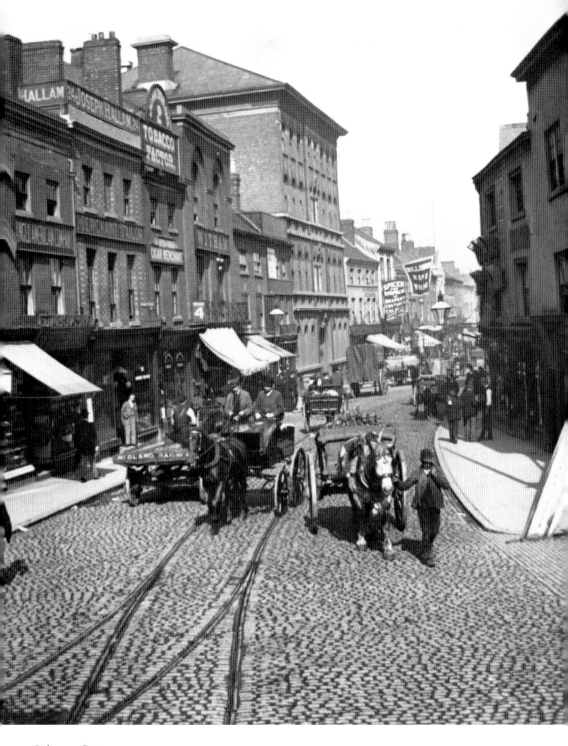

Belgrave Gate

A busy Belgrave Gate in 1900, viewed from the Haymarket. The Anglo-America Boot Repairing factory and Joseph Hallam, outfitter and tailors, are at No. 22 and 24 Haymarket respectively. Taylors, tobacconist and cigar factor, and Edward Witham, jeweller, are at No. 2 and 4 Belgrave Gate respectively. (Historic England Archive)

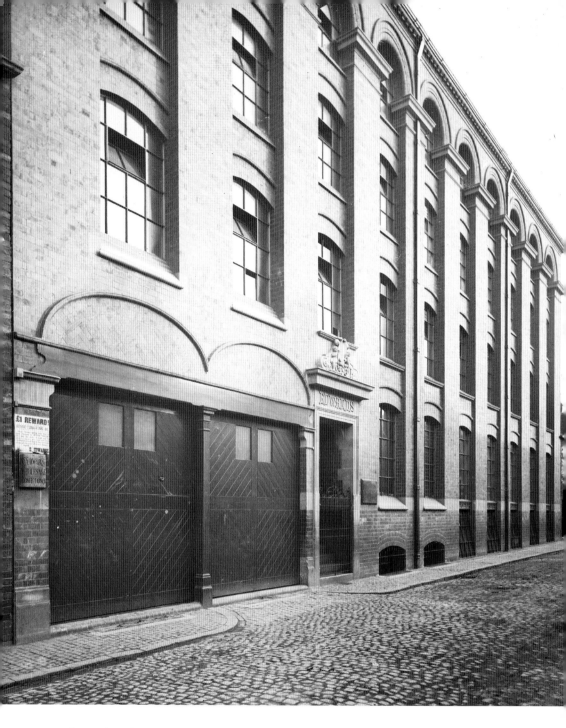

Edwin Edwards Confectionery Factory, York Street
This factory was designed by Arthur Wakerley. This photograph was taken in September 1889. On the left-hand side is a notice offering a reward for information leading to the conviction of stone throwers causing damage to the building. It was later a boot and shoe factory. Recently, the building has been converted into apartments and renamed York Place. (Historic England Archive)

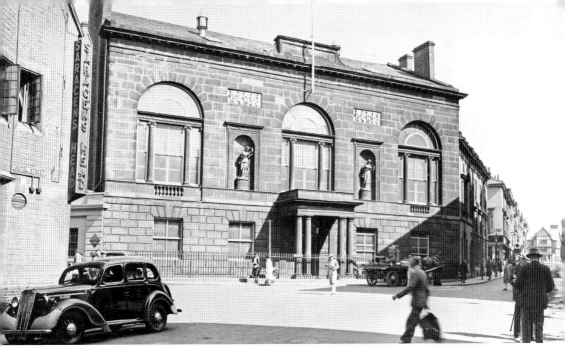

Above: The Assembly Rooms, Hotel Street
Hotel Street is named after this Grade I-listed building, which was intended as a hotel but opened as a coffee house and ballroom. Designed by John Johnson, it opened on 17 September 1800. It was later used as judge's lodgings during the assizes. The terracotta figures are by Felix Rossi RA. It is now called the City Rooms and is wedding venue and banqueting suite following sensitive restoration. (Historic England Archive)

Below: Friars Mill, Bath Lane
Dating from 1739, Friars Mill is regarded as Leicester's oldest surviving factory building. Built for Donisthorpe & Co., it takes its name from the Blackfriars of St Dominic, who once occupied this area. Refurbishment cost £6.3 million, and the buildings now accommodate a collection of fifteen flexible workspaces.

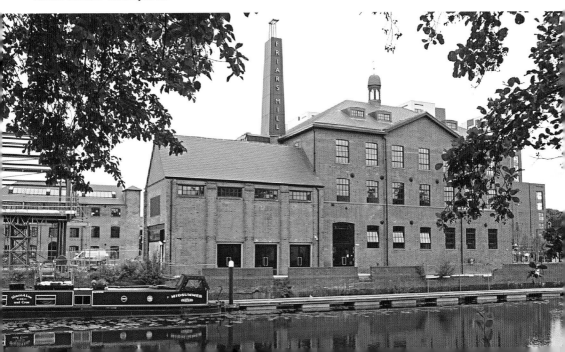

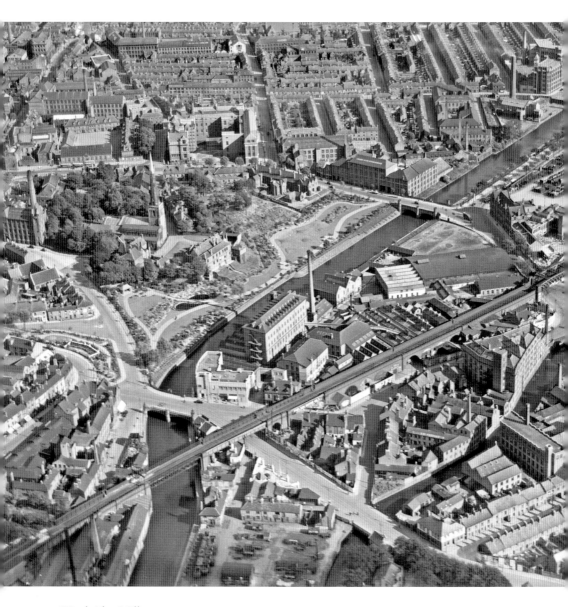

Westbridge Mill
The centrepiece of this aerial photograph, this impressive mill was designed by William Flint in 1844 for worsted spinners Whitmore & Sons, later to merge with Paton and Baldwins. Partially gutted by fire in 1979 but refurbished, it is now home to the Land Registry. It is one of only two mills listed in the 1826 Leicester Trades Directory, which have survived to the present day. (© Historic England Archive. Aerofilms Collection)

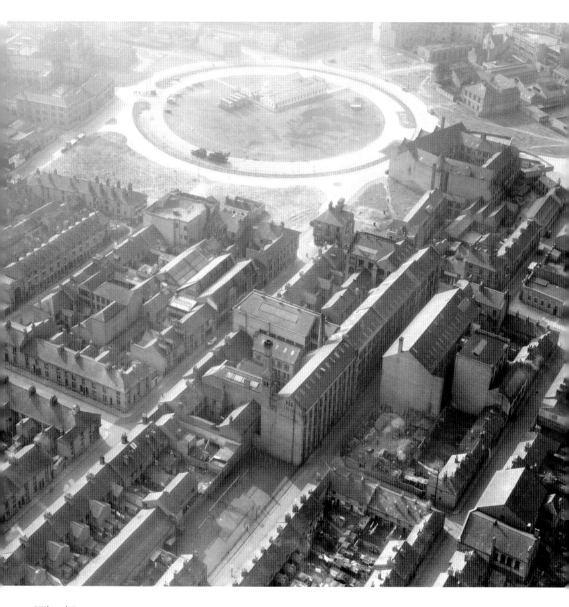

Wharf Street
Prominent in this aerial view of the Wharf Street area taken in 1947 is the land set aside for the
Lee Circle multistorey car park, which was not built until 1961. Of note is the large William
Raven's hosiery factory flanking both sides of Wheat Street. Both of these buildings, built in the
1880s, are still standing. (© Historic England Archive. Aerofilms Collection)

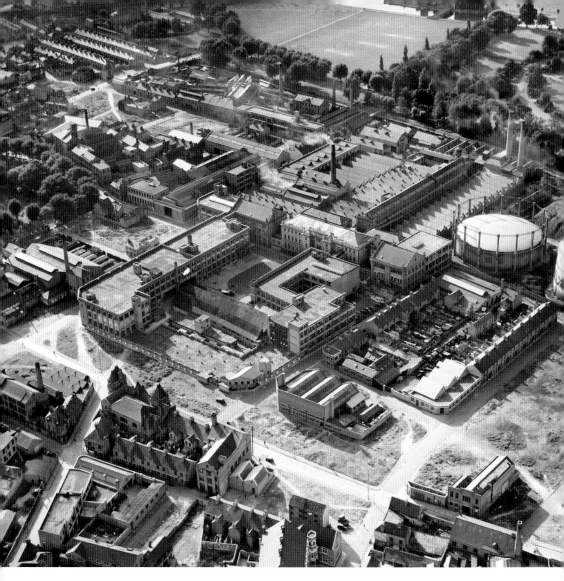

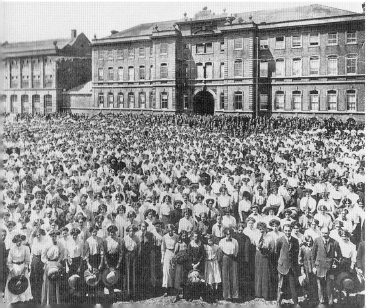

Above and left: Belgrave Gate and the Corah Textile Factory The aerial photograph from 1947 shows the extent of the large St Margaret Works of Nathaniel Corah & Sons Ltd, which for many years was Leicester's predominant textile manufacturer. This was the first factory in Leicester to be built with integrated steam power. The photograph of the large workforce was taken in 1919. (*Above*: © Historic England Archive. Aerofilms Collection)

People and Events

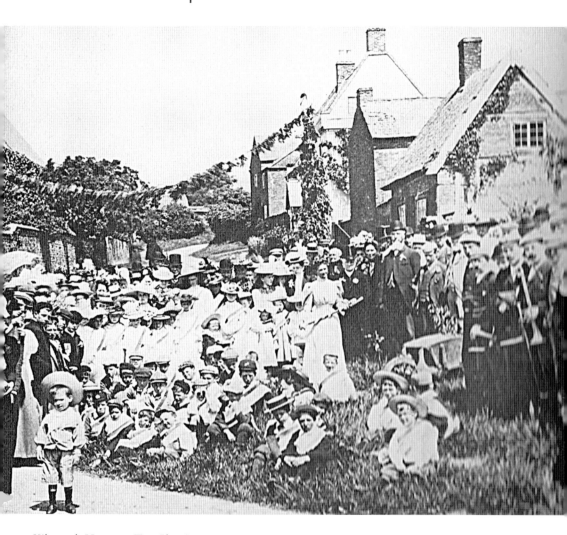

Kibworth Harcourt Tree Planting
Tree planting in Kibworth Harcourt, probably in Main Street, to celebrate the Diamond Jubilee of Queen Victoria in 1897. The parish council created a new Jubilee Green from a nearby former paddock to mark the Golden Jubilee of Her Majesty Elizabeth II in 2002.

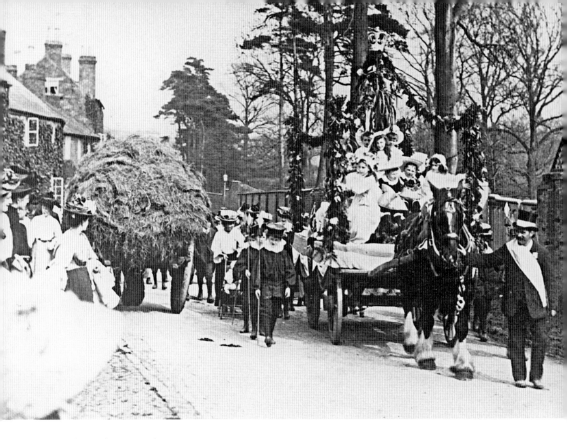

Kibworth Carnival, 1910

Kibworth Carnival was an annual event that may have had its roots in the annual fair when local farms would recruit the young men of the village to work in the fields, and the villagers celebrated the new life of spring. It survived until the 1990s.

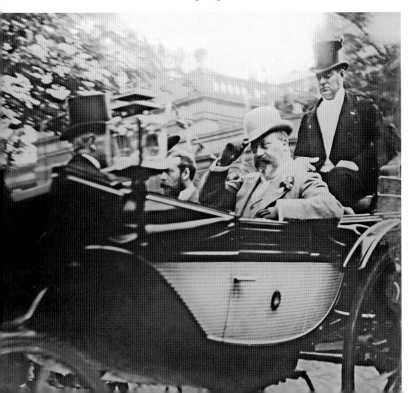

A Royal Visit to Leicester

The Prince of Wales, later Edward VII, and his son, the Duke of York, later George V, visiting the Royal Agricultural Society Show in Leicester on 20 June 1896. Edward pioneered royal public appearances as we understand them today. Leicester station is in the background. Leicester's clock tower was built to commemorate the show being held in the town.

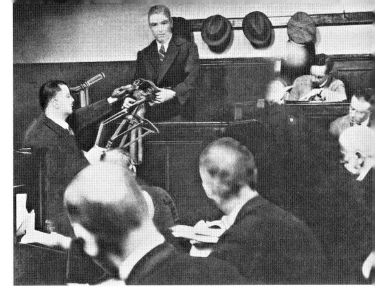

Leicester Crown Court, Leicester Castle
A witness giving evidence at Leicester Crown Court in Leicester Castle at the notorious trial of Ronald Light, accused of the murder of textile worker Bella Wright in July 1919 in the famous Green Bicycle Murder case. Against all odds, Light was acquitted. Photography inside courts during trials was made illegal in 1925.

St Nicholas Street
This historic house stood at the junction of Holy Bones. It is claimed John Bunyan lodged here in 1672 and John Wesley in 1753. A Roman mosaic was discovered in the cellars in 1898, which could be viewed on payment of three pence. It is now in the Jewry Wall Museum. St Nicholas Street was demolished in the 1960s.

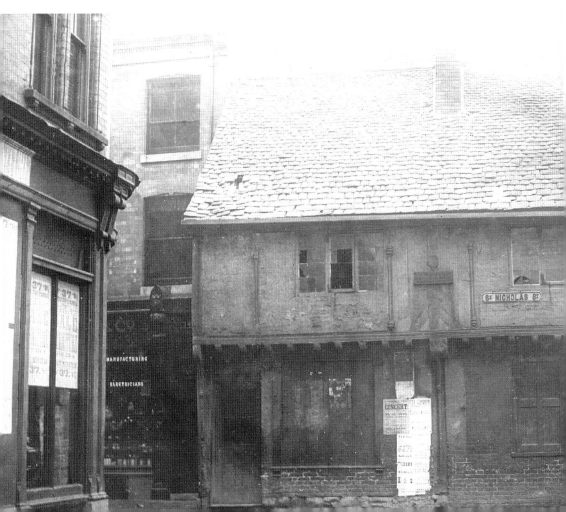

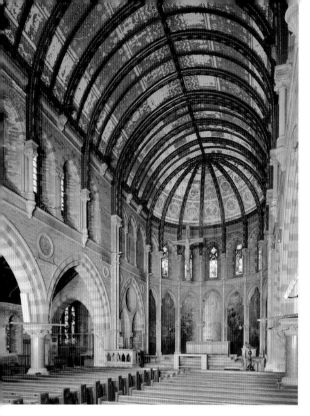

Left, below and opposite above: St Mark's Church, Belgrave Gate, Leicester Designed by Ewan Christian and commissioned by the Herrick family of Beaumanor Hall, St Mark's was built in 1869–71 on a challenging site that narrows on two sides. Its most famous priest was the Revd F. L. Donaldson, a leader of the Leicester March of the Unemployed to London in 1905. His socialist ideals led him to commission dramatic and controversial images, still surviving, by James Eadie-Reid (1859–1928) depicting Christ as the Apotheosis of Labour. (*Left*: © Crown copyright. Historic England Archive)

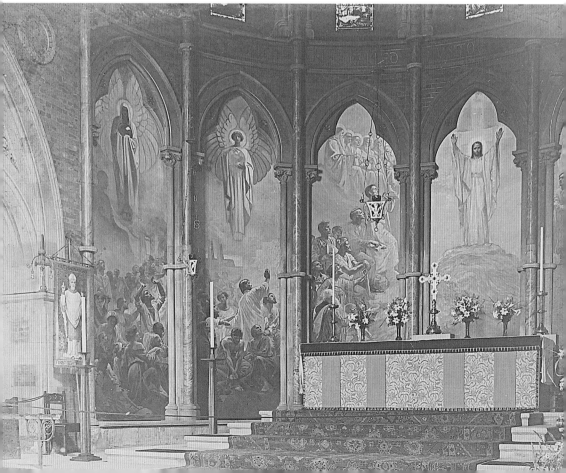

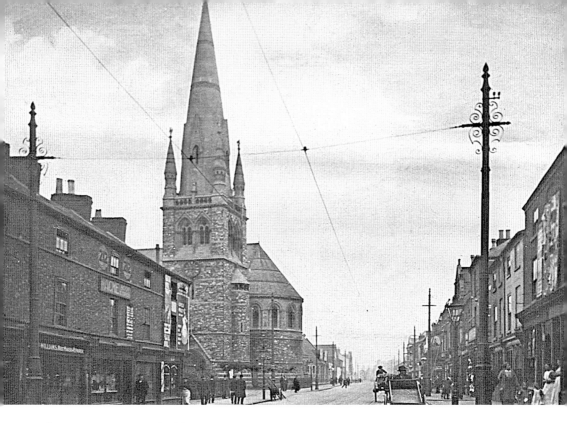

Below: Mount St Bernard Abbey

A view looking south across the west front of the guest house at Mount St Bernard Abbey, with a robed monk stood in the doorway. Mount St Bernard Abbey was the first permanent monastery to be founded in England after the Reformation. It was founded in 1835, although the building as it appears today was completed in 1844. (Historic England Archive)

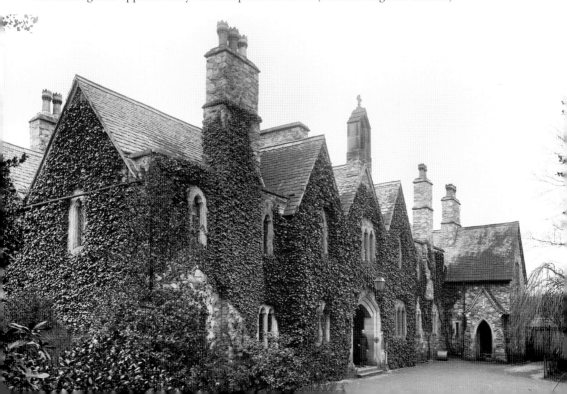

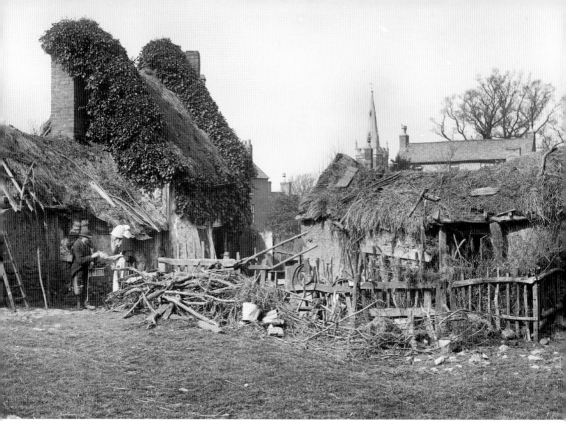

Frisby on the Wreake
A fascinating glimpse of late Victorian rural life, photographed by the London Midland & Scottish Railway and dated 14 March 1885. The group of thatched buildings is possibly a farmstead. In the foreground a man and a woman are selling goods. In the distance the spire of St Thomas of Canterbury's Parish Church can be seen. (Historic England Archive)

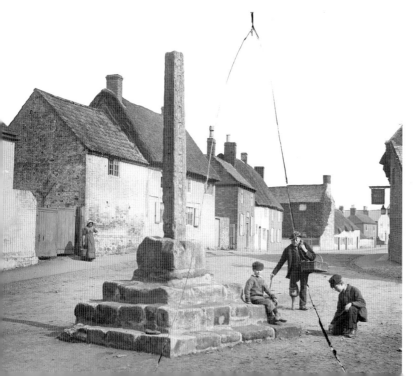

The Village Cross, Main Street, Frisby on the Wreake
Another view of rural village life in Frisby. Here, two children and a man wearing a wooden leg are near the village cross on Main Street, with a young woman carrying a pail on the far side of the road. It is likely that this photograph was staged, rather than being 'natural'. (Historic England Archive)

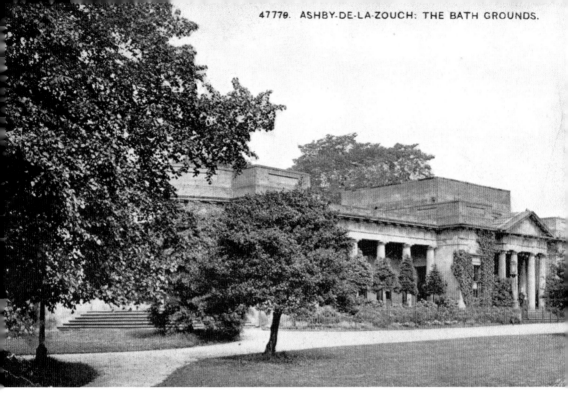

The Bath Grounds, Ashby-de-la-Zouch, Leicestershire, 1910/19
The Ivanhoe Baths opened in 1822, following the popularity of Sir Walter Scott's novel of the same name. The nearby park was laid out with a carriage drive and walks for sedate recreation. The baths were closed in 1884 and the buildings demolished during the 1930s. (Historic England Archive)

The Rectory, Swepstone
The photographer seems more interested in the woman holding a tennis raquet and wearing a large hat than in the architectural qualities of the rectory. Women's fashion started to change in the late Victorian period when they began to take part in sports such as tennis and needed clothes that would allow them to move more freely. (Historic England Archive)

The Railway Age

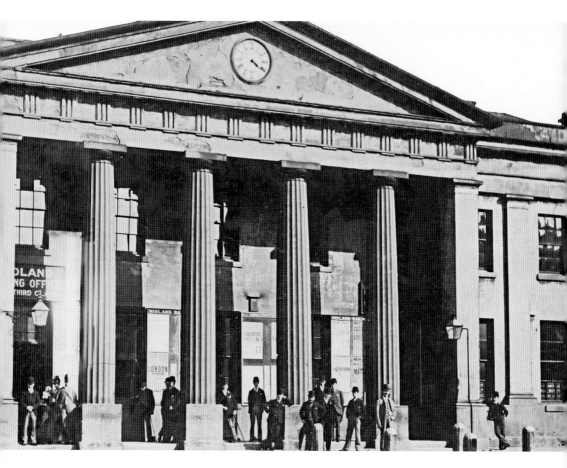

Above: The Midland Railway Station, Campbell Street
The impressive Midland Railway station viewed from London Road. The railway employees and passengers provide an indication of the scale of the structure. Built in 1840, it was laid out as a terminus station. Following the opening of the competing Great Central Railway, it was demolished in 1892 and replaced with the present station, which allowed for through trains.

Opposite above: Leicester Railway Station, London Road
The replacement for the Campbell Street station was built next door. This photograph shows the façade still under construction in 1892. St Stephen's Presbyterian Church was moved, stone by stone, to nearby De Montfort Street to make way for the station. The turret clock is the last on the network to be wound by hand. (Historic England Archive)

Opposite below: Railway Food Depot, Sussex Street
A photograph from 1927 of the Carmichael's Farm depot at the London & North West Railway warehouses on Sussex Street. The goods would have been waiting to be transported on a train or collected after their journey. The building is located on the south-east side of Sussex Street and is now a warehouse. (Historic England Archive)

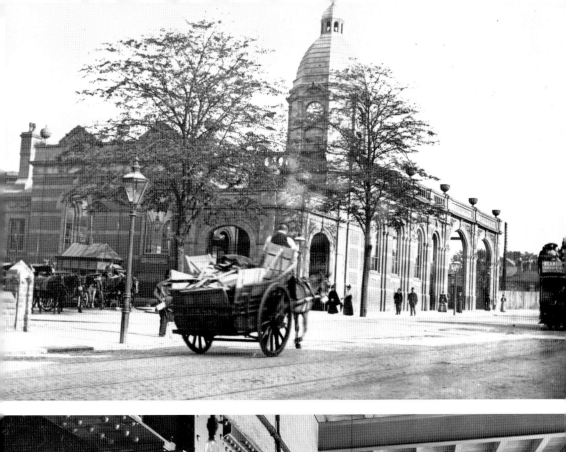

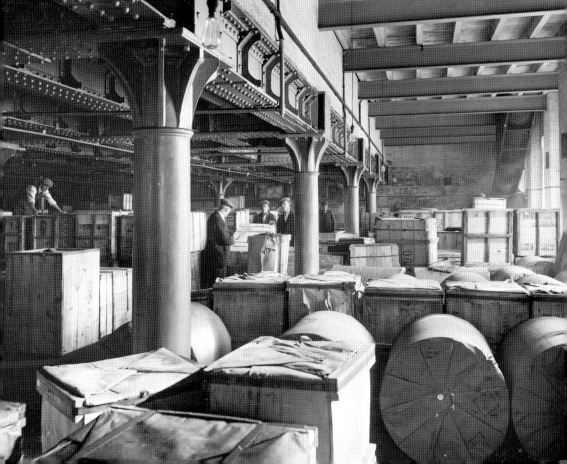

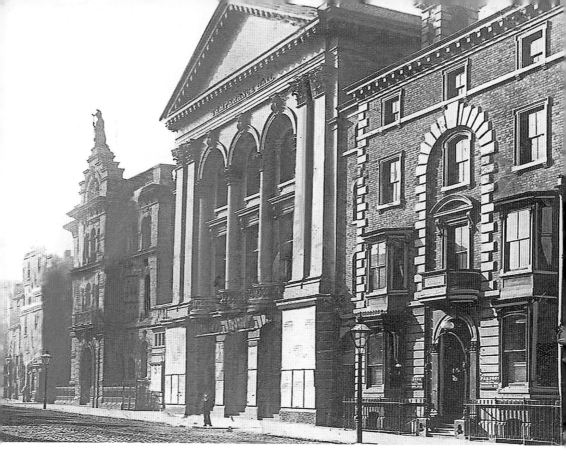

Above: Thomas Cook's Temperance Hall and Hotel
Eleven years after his first railway excursion in 1841, Cook built this temperance hall near the railway station. The hotel, completed first, had a print shop, offices and rooms for his family. These were the first public buildings in Leicester with a piped water supply. The hall was demolished in the 1960s. The hotel was converted into shops.

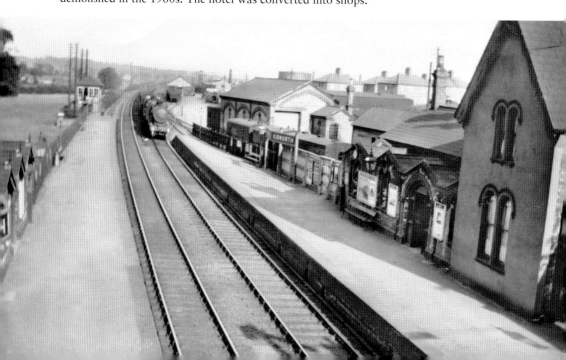

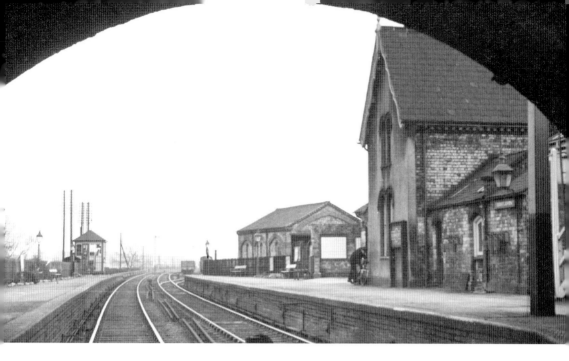

Above and opposite below: Kibworth Railway Station
Kibworth railway station was built by the Midland Railway in 1847 in what has been described as an 'attractive Midland Ecclesiastical Gothic' style. This photograph is from an extensive collection by the Revd H. D. E. Rokeby of Thetford. Also, a view from the bridge, with a train approaching from Market Harborough, but with no station staff or passengers on the platform. (Historic England Archive)

Below: Kibworth Railway Station
An early photograph of the stationmaster, his family and staff standing on the up platform (towards Market Harborough). The main station buildings were on the down platform. It seems that this type of photograph was a tradition, at least along this line, as there are similar photographs taken at neighbouring stations.

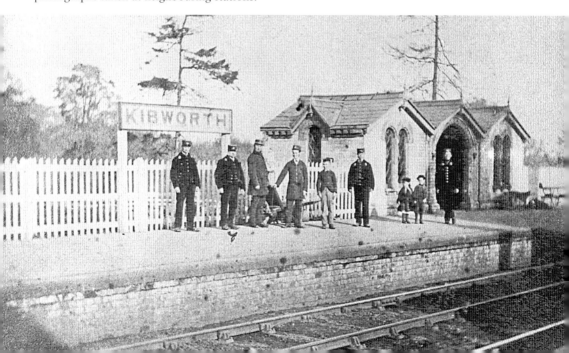

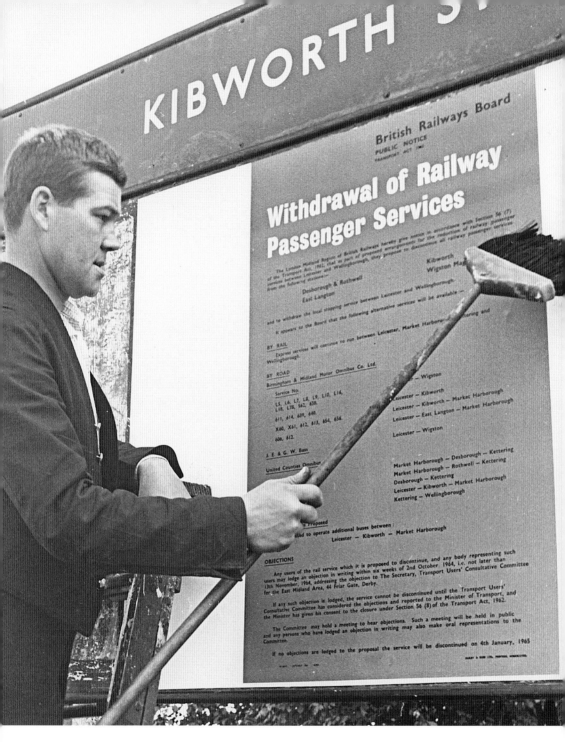

Closure of Kibworth Railway Station

A railway employee posts the official announcement that Kibworth railway station is to close as part of the Beeching Plan. Goods services ended on 4 July 1966 and the station closed to passengers on 1 January 1968. A small residential development has been built on the former goods yard and sidings. The station building has been converted into offices.

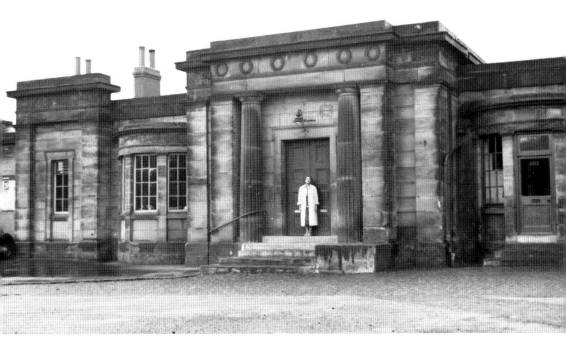

Above: Ashby-de-la Zouch Railway Station
Sir Walter Scott's *Ivanhoe* popularised Ashby, and people flocked to the town. The railway station was built in neoclassical style with Doric columns and opened in 1849. Tramlines of the Burton & Ashby Light Railway are still visible in the forecourt. The station closed in 1964. The building is Grade II* listed and has been refurbished. (Historic England Archive)

Below: Loughborough Central Station, 1956
The station was opened by the Great Central Railway on 15 March 1899 and closed on 5 May 1969. It was reopened by the Great Central Railway as part of the restored heritage railway in 1974. The buildings, all Grade II listed, are unique on a preserved railway, being the only station with a complete canopy, the longest in railway preservation. (Historic England Archive)

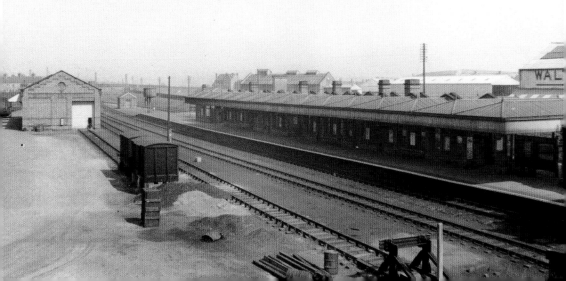

Leicester and Leicestershire Parks and Open Spaces

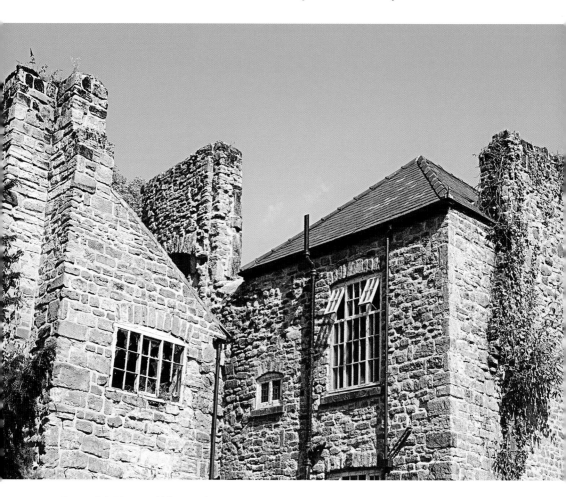

Cavendish House, Abbey Park, Leicester
Built by Henry Hastings, Earl of Huntingdon, using stone from the ruins of Leicester Abbey, which he acquired after the Dissolution of the Monasteries. In 1613 the house was purchased by William Cavendish, 1st Earl of Devonshire. It served as headquarters for Charles I before the Battle of Naseby and was then plundered and burned by royal troops.

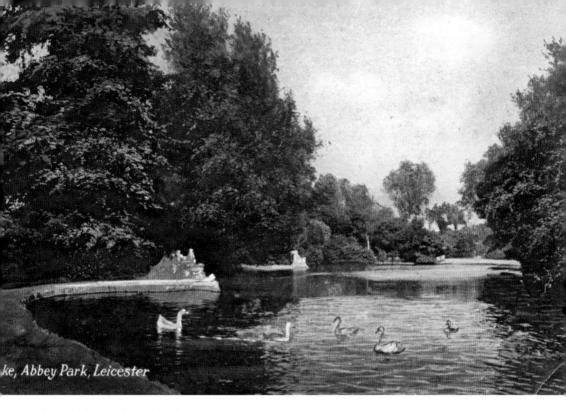

ke, Abbey Park, Leicester

Above, below and overleaf above: Abbey Park
Views from the 1930s of the lake, pavilion and Japanese Garden of Leicester's expansive municipal park, which grew out of the land owned by the former Augustinian Abbey of St Mary de Pratis. Abbey Park was purchased from the Earl of Dysart in 1876. A competition to design a new municipal park was won by William Barron & Sons. They designed the gardens, bandstands and bridges. Local architect James Tait designed the pavilion and lodges. The park was officially opened by the Prince and Princess of Wales in May 1882. (Historic England Archive)

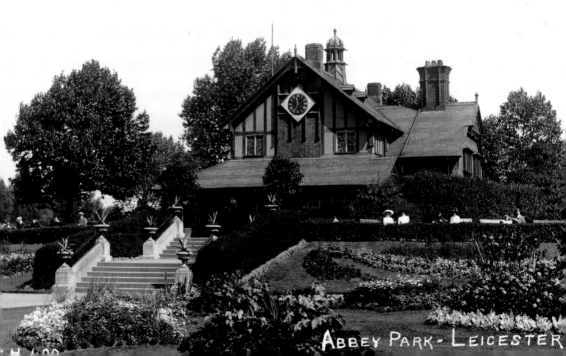

ABBEY PARK · LEICESTER

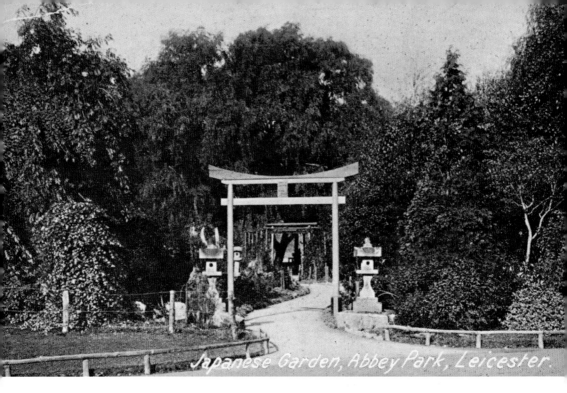

Japanese Garden, Abbey Park, Leicester.

Below: The Pavilion, Spinney Hill Park

The 36 acres and three rods of parkland cost Leicester Corporation £18,000 in 1885. Paths were laid out, trees planted, and the pavilion constructed. The granite fountain in the park was donated by a wealthy pork and cheese merchant and local councillor Mr Samuel Mather. This photograph was taken on 11 March 1890 by Henry Bedford Lemere. (Historic England Archive)

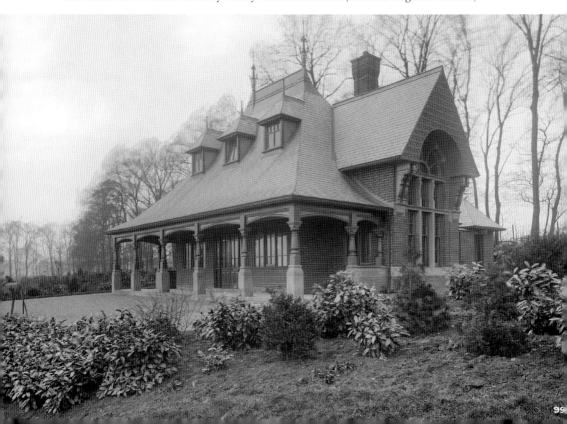

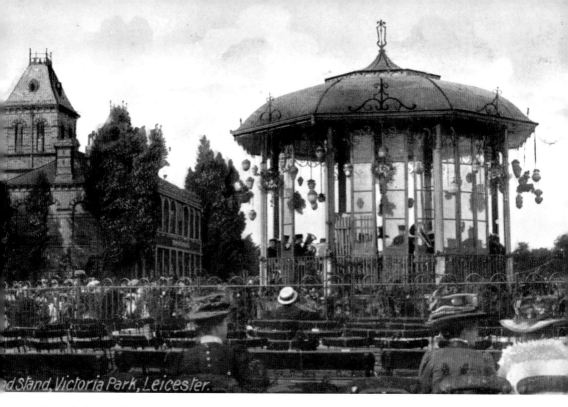

Stand, Victoria Park, Leicester.

Above, below and overleaf above: Victoria Park

Laid out on part of the historic South Field of the town, Victoria Park was a racecourse from 1806 until 1883, and then a public park. The grandstand was used as a pavilion until damaged by a German bomb in 1940. It was then demolished, and a new pavilion built on the same site in 1958. Leicester City Football Club played here between 1884 and 1890 when they were known as Leicester Fosse. (Historic England Archive)

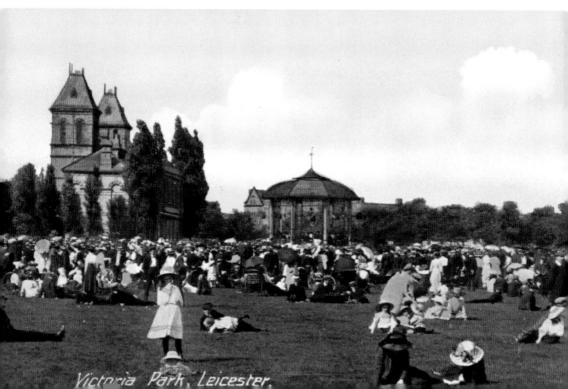

Victoria Park, Leicester.

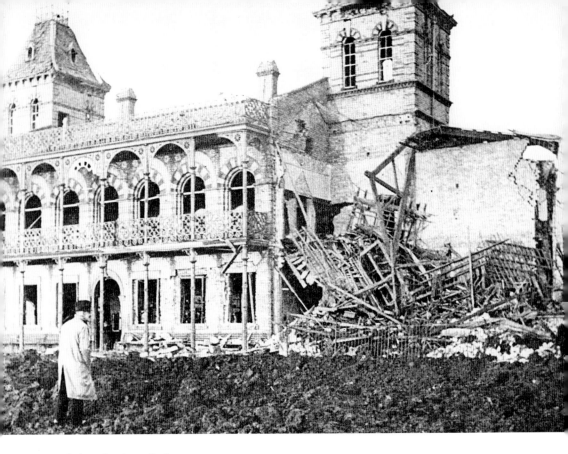

Below: Bradgate Park
The estate, covering 850 acres, was put up for sale by the Grey family (descendants of Lady Jane Grey) in 1925. Local industrialist Charles Bennion, the founder of the British United Shoe Machinery Co., purchased the park for nearly £16,000. It was presented formally to the people of Leicestershire on 29 December 1928, just three months before his death. (Historic England Archive)

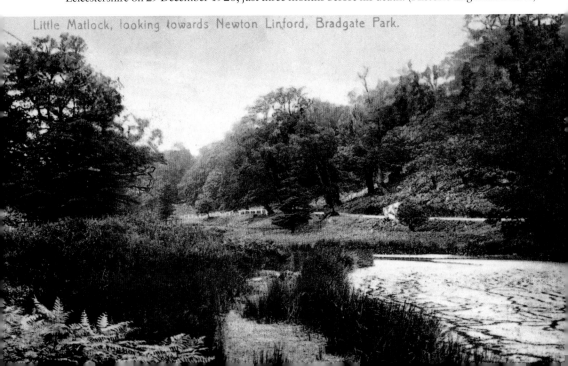

Little Matlock, looking towards Newton Linford, Bradgate Park.

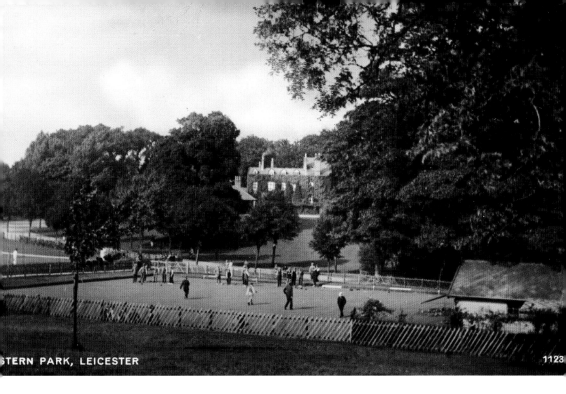

STERN PARK, LEICESTER 1123

Above and below: Western Park

Occupying 178 acres of what was once the ancient Leicester Forest, this is Leicester's largest municipal park. The land was purchased by the Corporation from the trustees of Sir John Mellor in 1899 at a cost of £30,000. The main drive features a wide avenue of trees, which were planted for the inaugural opening. The Roman road from Leicester to Mancetter is thought to cross the site. (Historic England Archive)

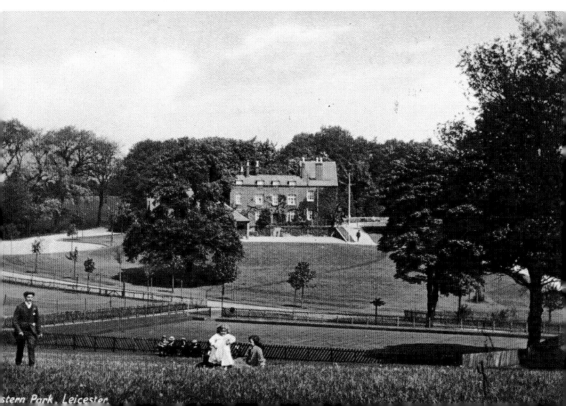

stern Park, Leicester

The County Towns and Villages

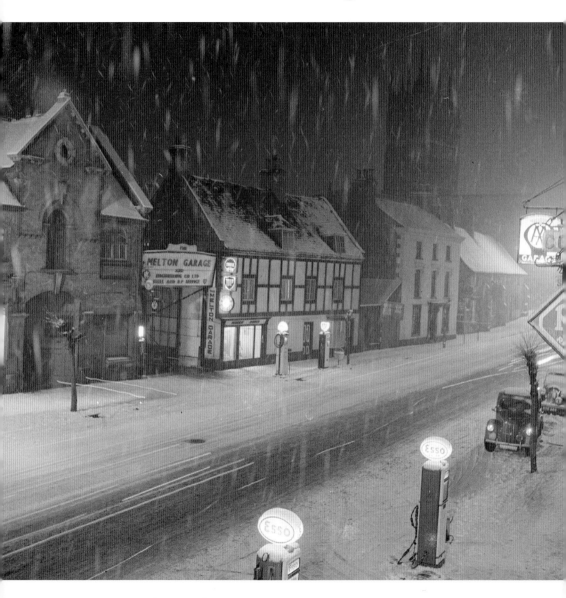

Burton Street, Melton Mowbray
A view taken in the early 1950s of Burton Street in Melton Mowbray at night and covered in snow, showing Esso petrol pumps in the foreground and buildings on the west side of the street from the Melton Garage to the tower of St Mary's Parish Church. (© Historic England Archive)

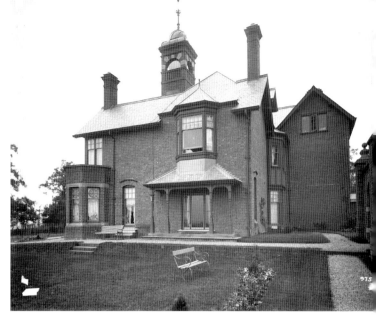

The Elms, Melton Mowbray
The exterior garden front of The Elms, a Victorian house designed by architect Arthur Wakerley as a hunting lodge at an unidentified location in Melton Mowbray. The exact location is not documented, but it is not believed to be the building of the same name that once stood on Sherrard Street. (Historic England Archive)

Ankle Hill, Melton Mowbray
Another dignified house designed by Arthur Wakerley. This photograph was taken in 1889 by Bedford Lemere & Co. The area was so named following a Civil War battle which, it is said, caused blood to lie ankle deep. However, the same name existed elsewhere in the town before the Civil War. (Historic England Archive)

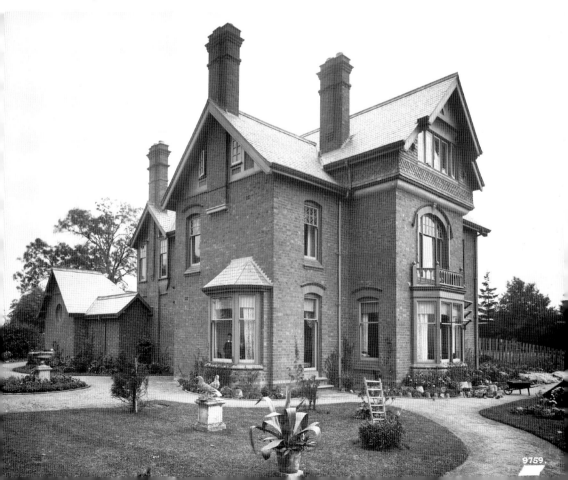

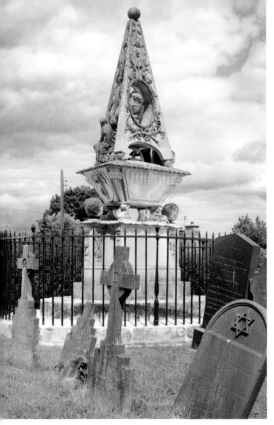

Left: The Squire Monument, St James' Parish Church, Burton Lazars

This monument commemorates William Squire, a local weaver who died in 1781. It is said that his entire fortune of £600 was spent on creating it. Grade II* listed, it is 6 metres high consisting of an obelisk on top of an urn, supported by four real cannon balls. It was reported as 'at risk' in 2014 but funding from Historic England and Melton Borough Council has enabled complete restoration. (© Historic England Archive)

Below: Holly Tree Farm, Hoton

Grade II listed, many of the original construction techniques of this early seventeenth-century barn can still be seen, including the upper cruck and the herringbone brick infill. This photograph was taken in 1953 by Maurice Willmore Barley, the distinguished historian and author of *The English Farmhouse and Cottage* (1961). The adjacent farmhouse is also listed. (Historic England Archive)

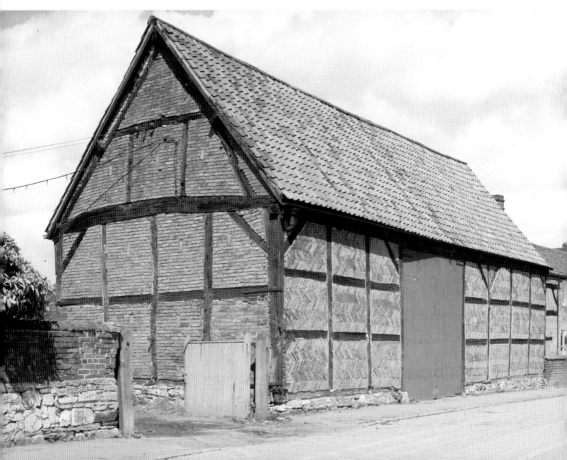

Right: The Gate Hangs Well, Fosse Way, Lewin Bridge, Syston
The derivation is obscure: 'This Gate Hangs Well & hinders none, refresh & pay & travel on.' Possibly pubs so named were near toll gates on turnpikes or where tolls were charged to use bridges. This pub is near the Lewin Bridge, where tributaries of the River Wreake converge and flooding occurs. It is also on the Roman Fosse Way. (© Historic England Archive)

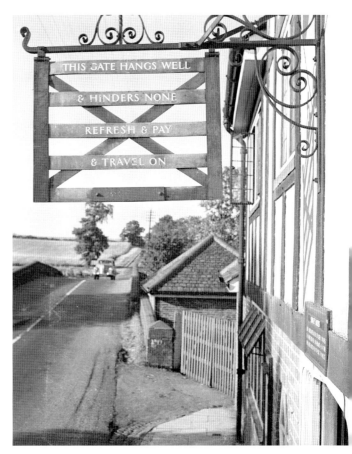

Below: The Old Ship, Bradgate Road, Anstey
This fifteenth-century hall is notable for its decorative spare truss, which separated off a passage at the lower end of the hall. The Martin family, who lived in Anstey from at least 1341, regarded this as their ancestral home. Between 1760 and 1850, the building was divided into separate tenancies. These photographs are from November 1955, just before it was demolished. (Historic England Archive)

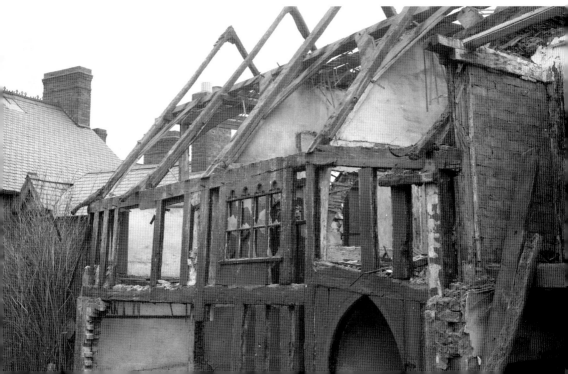

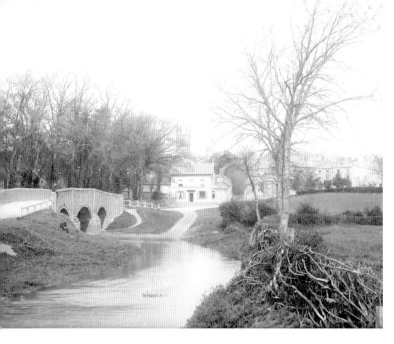

The River Swift Bridge, Lutterworth
The Rugby Road, now the A426, looking north towards the bridge over the River Swift, which was built in 1778 next to the ford. The tower of St Mary's Church can be seen in the distance. Legend says that John Wycliffe's bones, having been burned, were thrown into the river near this location. It was photographed by Henry Taunt in 1878. (Historic England Archive)

Below: Church Street, Lutterworth
Also the work of Henry Taunt, this is the view along Church Street towards St Mary's Church with the Angel Inn in the foreground. The Angel was first recorded as an inn in 1791 and is the site of the private house where the dissident Protestant reformer John Wycliffe (1320s–84) is said to have translated the Bible from Latin into English. (Historic England Archive)

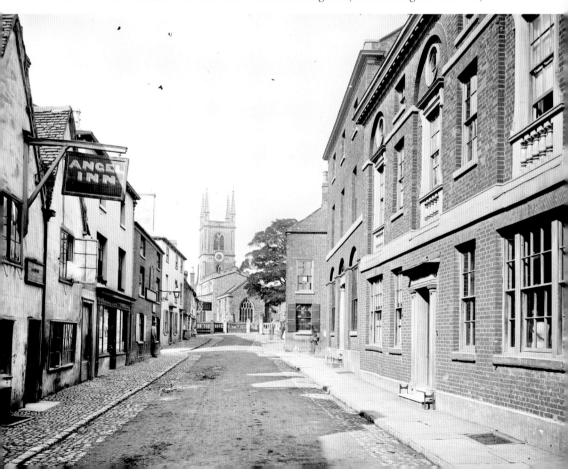

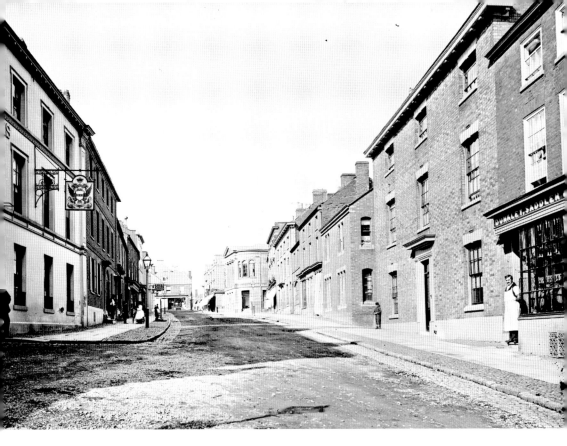

High Street, Lutterworth
In former times, Lutterworth's High Street was on the main road from Leicester to Rugby and on to the market town of Southam in Warwickshire. In modern times, increasing traffic congestion has caused this road to be declared an Air Quality Management Area. The Georgian splendour of the frontage of the Denbigh Arms Hotel hides an earlier timber-framed building. (Historic England Archive)

St Mary's Parish Church, Lutterworth
The exterior of this thirteenth-century church where the religious reformer John Wycliffe was rector between 1374 and 1384 under the protection of John of Gaunt. It is believed that here Wycliffe produced the first translation of the Bible from Latin into English. The church had a spire until it collapsed in a storm in 1703. (Historic England Archive)

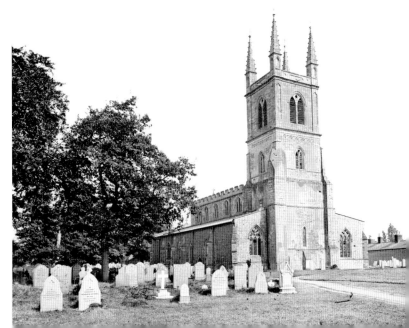

Above: The Town Hall, Lutterworth
The architect of this dignified building was Joseph Aloysius Hansom (1803–82), who also built Birmingham Town Hall and the Hansom Hall in Leicester, which was designed as a Baptist chapel. Hansom also took out the first patent of the horse-drawn hansom cab, the first one taking to the road in nearby Hinckley in 1835. (© Historic England Archive)

Opposite above: St Leonard's Church, Misterton
In the shadow of Lutterworth, the tiny settlement of Misterton is represented now by few buildings other than the church and Misterton Hall. The tower is mainly fourteenth century with a broach spire and battlemented chancel and aisles. It was restored in 1863. This image is from 1878 and is by Henry W. Taunt. (Historic England Archive)

Below: The Wheatsheaf Inn, Leicester Road, Thurcaston

Photographed in 1942 by Alfred Newton of Leicester, the Wheatsheaf is a former coaching inn dating to the 1600s. The original inn was the building on the junction of Mill Lane and Leicester Road. A newspaper reported in 1875 that the innkeeper had been arrested for being 'very drunk' in charge of a horse and cart. (Historic England Archive)

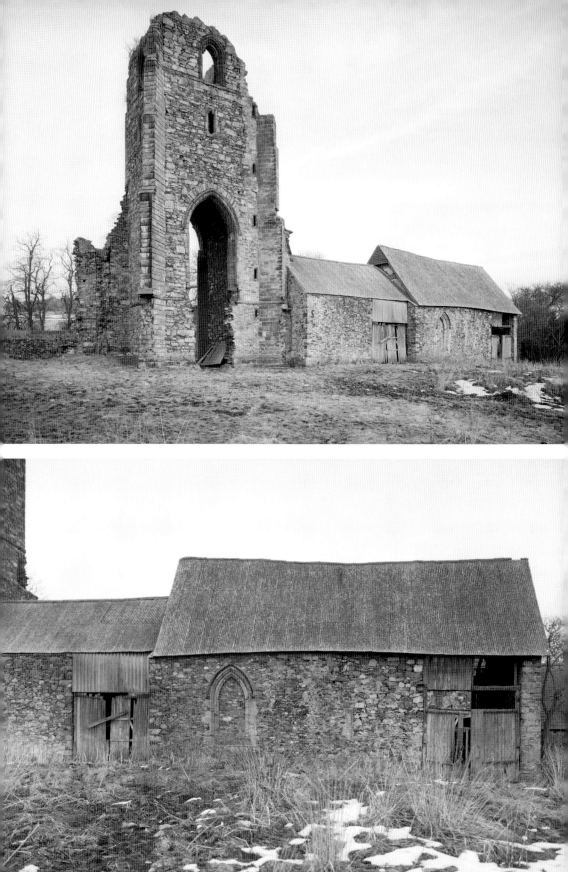

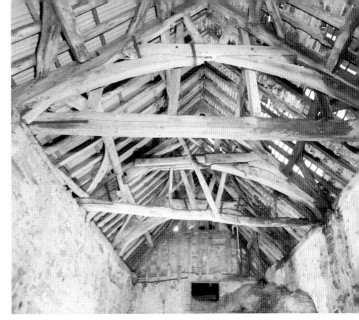

Right and opposite: Ulverscroft Priory

An Augustinian priory founded as an Eremite hermitage by Robert de Beaumont, 2nd Earl of Leicester, in 1139, ruinous since its dissolution in 1539. The photographs show the tower and interior and exterior of the guest hall. Surveyed by former Leicester borough engineer and archaeologist William Keay and purchased by Sir William Lindsay Everard in 1927 to arrest its decay, it remains in private ownership. (*Right and opposite below*: © Crown copyright. Historic England Archive; *opposite above*: Historic England Archive)

Below and overleaf above: Ashby-de-la Zouch Castle

Popularised by Sir Walter Scott's novel *Ivanhoe*, this fortified manor house from the twelfth century was the seat of William, Lord Hastings, who in the fifteenth century developed it into a castle, photographed on 25 May 1892 possibly as part of a survey of the site. The kitchen tower and north wall of the chapel dominate. (Historic England Archive)

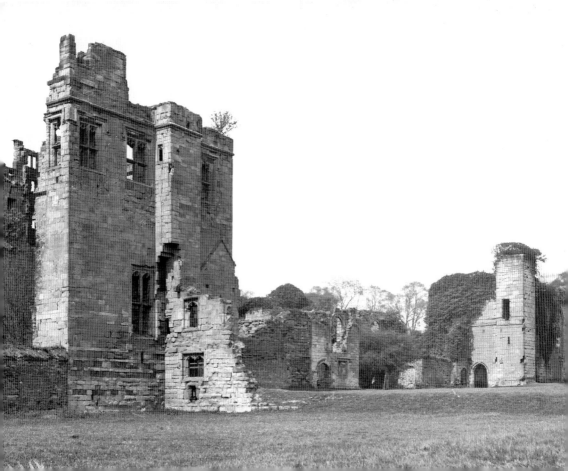

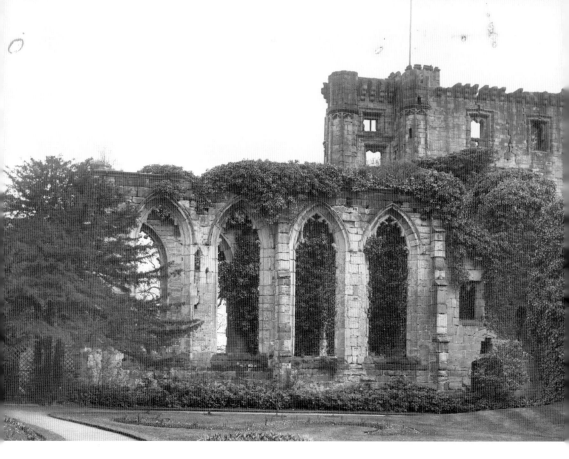

Below and opposite above: Kirby Muxloe Castle
Heritage England describes Kirby Muxloe Castle as a 'spectacular example of a late medieval quadrangular castle of the highest status'. The earlier print, looking over the moat to the west tower and gatehouse, is not dated but shows the structure of the castle before repairs were undertaken when the site came into the guardianship of English Heritage in 1911. These works were completed by 1913. (*Below*: Historic England Archive; *opposite above*: © Historic England Archive)

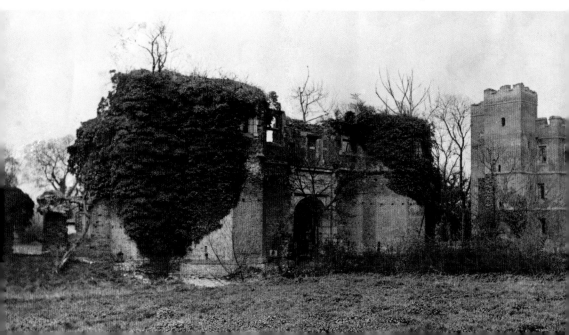

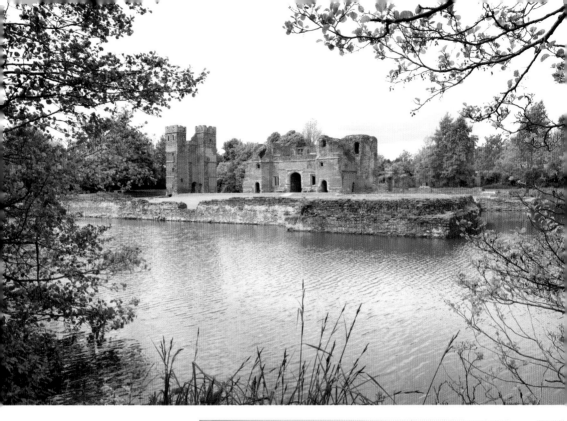

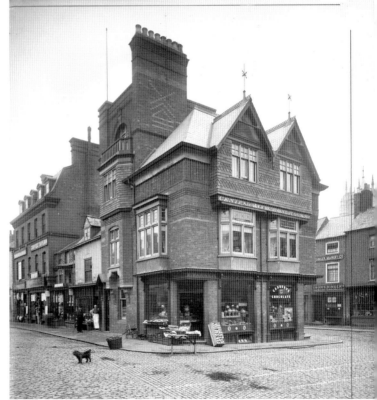

The Market Place, Melton Mowbray
A view of the shops in the historic Market Place in Melton Mowbray with the Central Refreshment rooms in the foreground and the tower of St Mary's Church visible in the background. Melton was an important meeting point for the surrounding settlements. The Bedford Lemere daybook records the architect and client as Arthur Wakerley. (Historic England Archive)

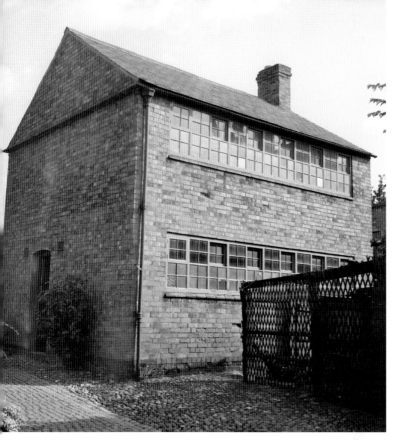

Left and below: Framework Knitters Workshop, Nos 42–44 Bushloe End, Wigston Photographed in 1972, these images are of the frame shop and the winding frame and knitting frame in the machine room. The frame shop dates to the late Victorian era and stands in the rear yard of the former Master Hosier's house. This workshop was built in 1890 and operated until the 1940s, which is evidence that knitting frames and specialist domestic production remained viable as late as the post-war years. (*Left*: © Historic England Archive; *below*: © Crown copyright. Historic England Archive)

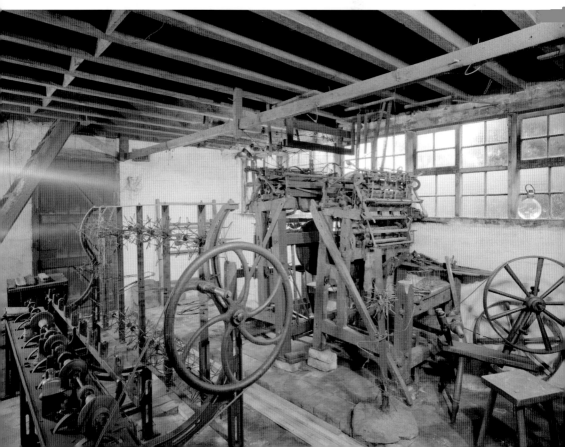

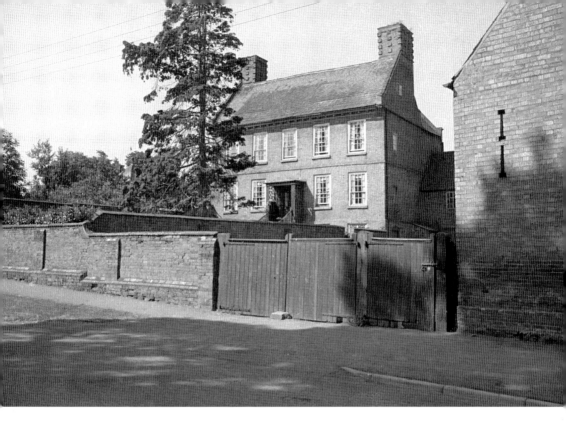

The Manor House, Willoughby Waterleys
The west façade of the manor house in Willoughby Waterleys set behind an attached red-brick garden wall. The farmhouse dates from 1693 and the site includes other red-brick farm buildings located around a yard, north of the house. (Historic England Archive)

Right and overleaf: The Three Swans Hotel, Market Harborough
One of several coaching inns alongside the High Street and Market Square in Market Harborough on the Leicester to London turnpike, it dates to at least the early sixteenth century. The name changed from the Swan to the Three Swans in around 1790. The aerial views overleaf show the former cattle market, now the St Mary's Place shopping precinct, and the historic centre of the town. (*Right*: © Historic England Archive; *overleaf*: © Historic England Archive. Aerofilms Collection)

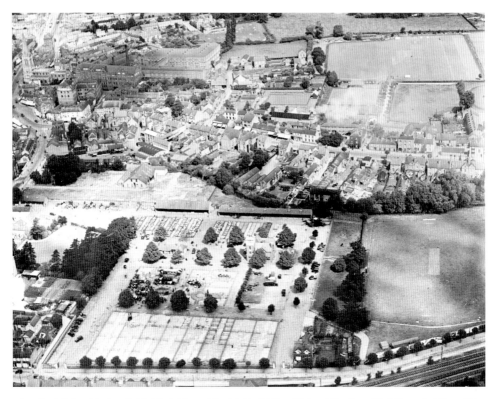

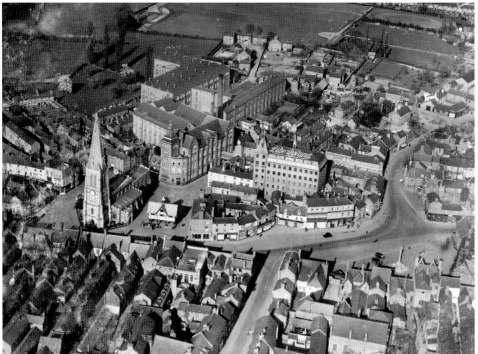

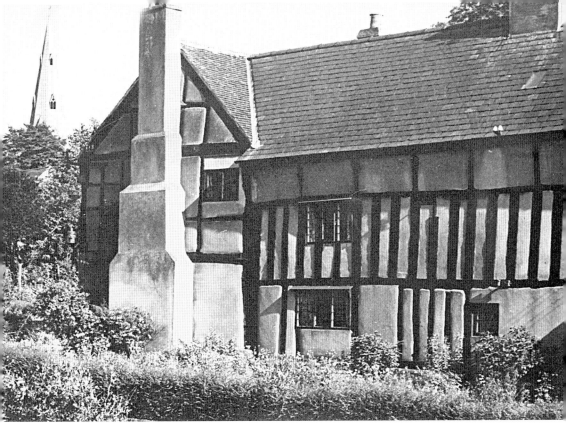

Yeoman's Cottage, South Kilworth

A photograph by Frederick Attenborough, father of the famous brothers David and Richard, illustrating research by W. G. Hoskins, founder of the study of English local history. Hoskins was a lecturer at University College in Leicester when Attenborough was the principal. The building is a fine example of a prosperous yeoman's house from the mid-sixteenth century. It is still a family home.

Ingarsby Barn
Ingarsby is one of the many deserted medieval villages in Leicestershire researched by the pioneering English local historian W. G. Hoskins. Originally a Danish settlement, it was depopulated in 1469. The barn is part of the fifteenth-century moated manor of Ingarsby Old Hall built by Sir Brian Cave, sheriff of Leicestershire, when he acquired the manor after the Dissolution of the Monasteries.

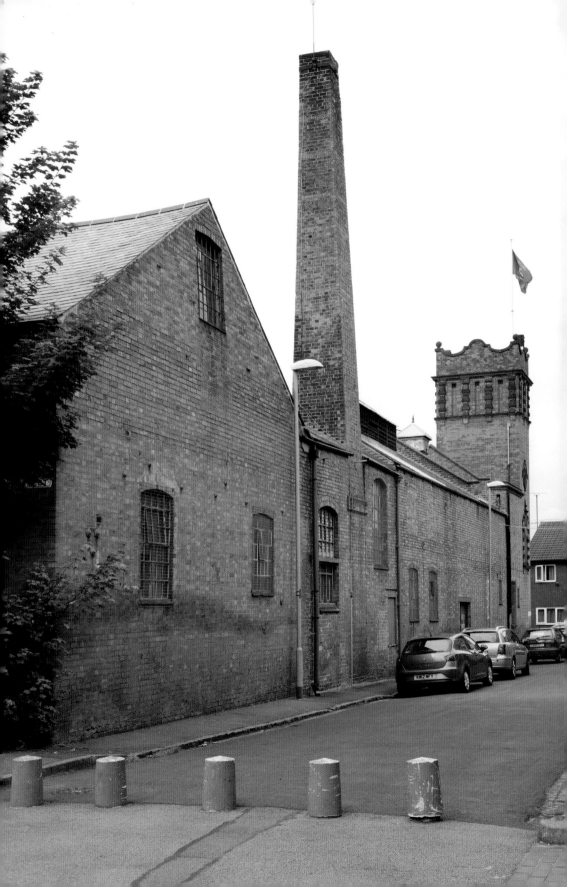

Above, below and opposite: The John Taylor Bell Foundry, Loughborough
The last major bell foundry in Britain was built in Freehold Lane, Loughborough, in 1839, continuing a heritage of bell founding that began with Johannes de Stafford of Leicester in the fourteenth century, who was working close by. After several financially unstable decades, the foundry is still in production casting bells for churches across the world and is campaigning to preserve its heritage for the future. (© Historic England Archive)

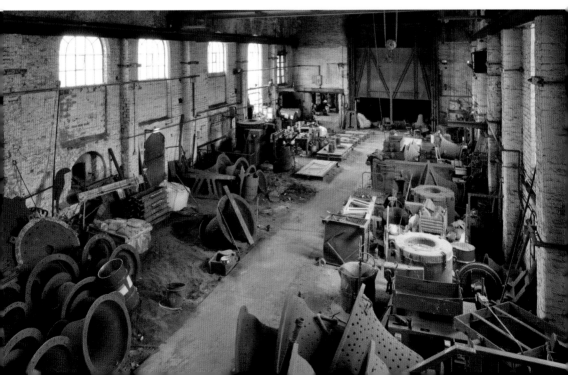

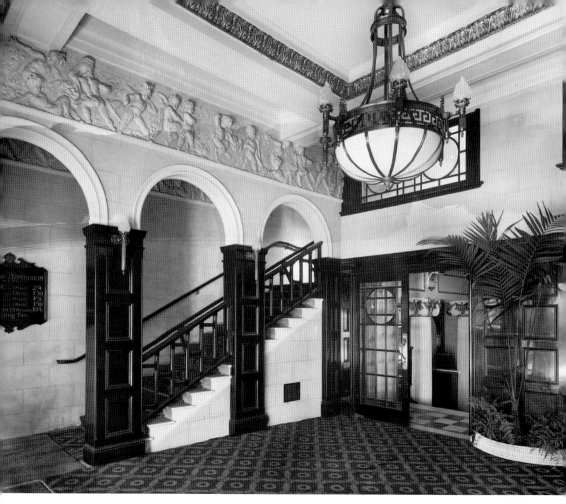

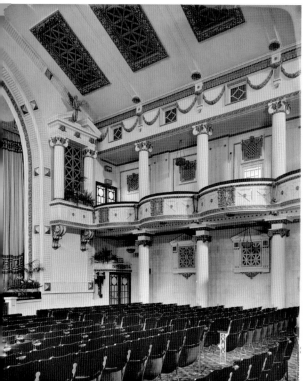

Above and left: The Victory Cinema, Biggin Street, Loughborough

The Victory Cinema was designed by Victor Peel, the architect based in Temple Street, Birmingham, who is arguably better known for his Catholic churches, working in Modernist styles, but who also built the Picture Palace in West Bromwich. He served as president of the Incorporated Association of Architects and Surveyors for some years. The Victory opened in 1921 and closed in the 1960s.

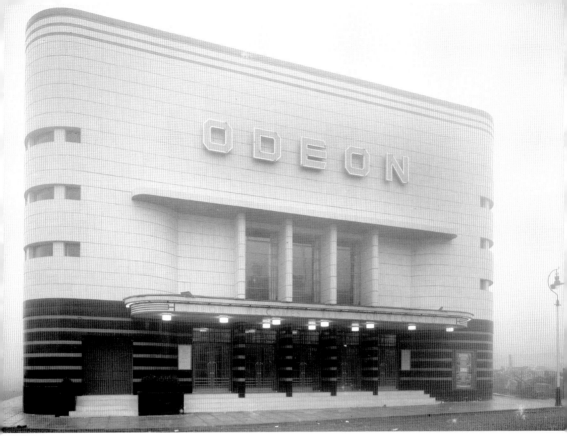

Above and below: Odeon, Baxtergate, Loughborough
A fine example of the numerous cinemas designed for Oscar Deutsch by Harry Weedon and Arthur J. Price. The cinema left the Odeon chain in December 1967 to become a Classic cinema. It closed in January 1974 and has since been used as a bingo hall. It was Grade II listed in 2007. (Historic England Archive)

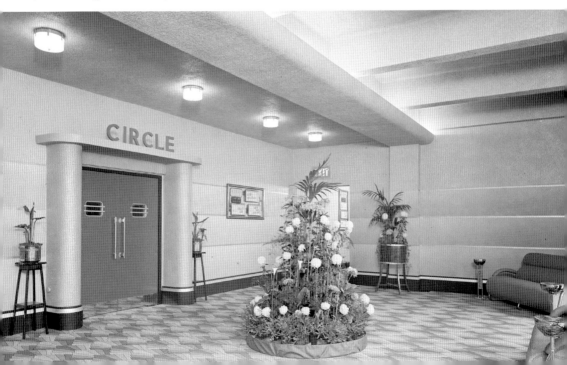

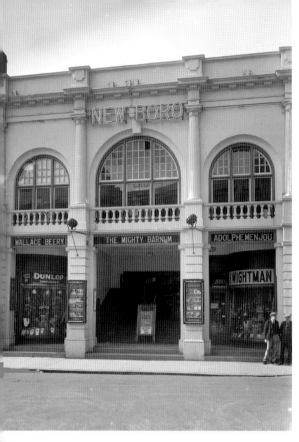

Left and below: The Odeon Cinema, Hinckley

Built in 1913 as the Hinckley Theatre and Picture House and designed by J. R. Wilkins of Oxford, the construction and fittings were by local craftsmen. It was refurbished and renamed the New Boro' Cinema in 1935 and became an Odeon in January 1936, three months after this photograph was taken by John Maltby. It was demolished in 1962. (Historic England Archive)

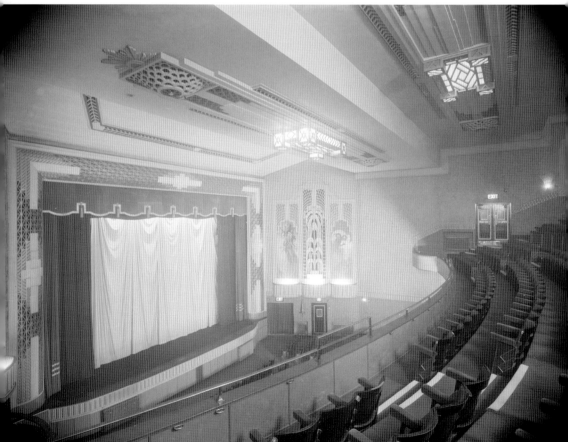

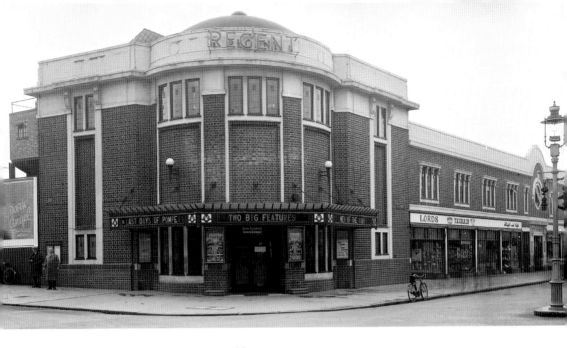

Above and below: Regent Cinema, Hinckley
The building opened as a theatre in 1929, designed by Horace G. Bradley to accommodate 1,600 seated and a further 500 standing customers. It was the first theatre in Hinckley to install sound. The Regent became an Odeon cinema, then part of the Gaumont chain and later a Classic theatre. The auditorium was demolished in May 2014, but the shop façades have survived. (Historic England Archive)

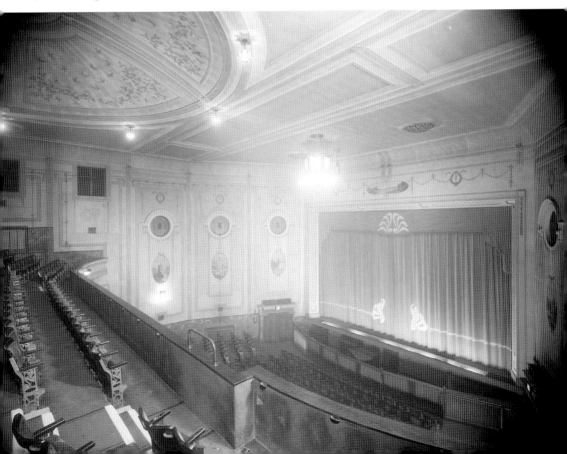

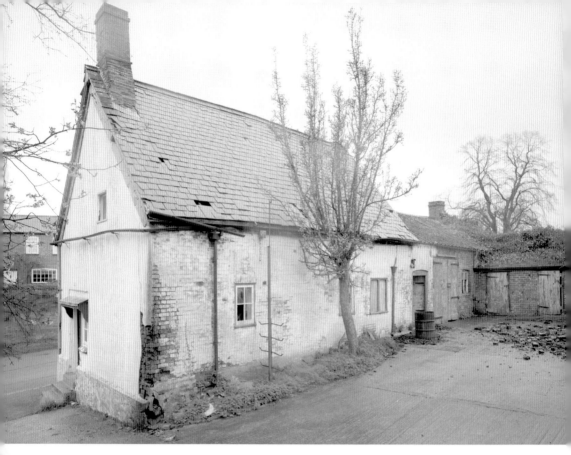

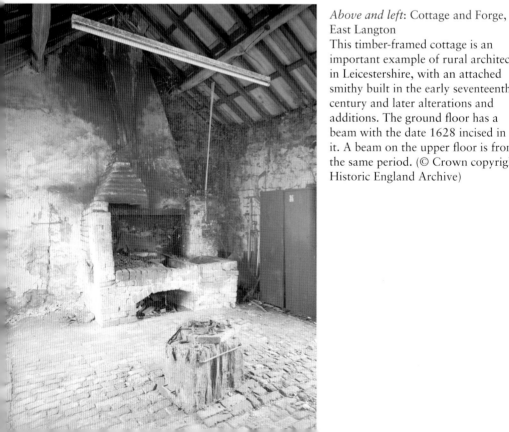

Above and left: Cottage and Forge, East Langton
This timber-framed cottage is an important example of rural architecture in Leicestershire, with an attached smithy built in the early seventeenth century and later alterations and additions. The ground floor has a beam with the date 1628 incised in it. A beam on the upper floor is from the same period. (© Crown copyright. Historic England Archive)

Above: The Old Manor House, Nos 11–12 Sparrow Hill, Loughborough
This fifteenth-century timber-framed house was acquired by Edward, Baron Hastings, in 1557. His son Henry Hastings was born here in 1609. In the early 1900s it was used by hardware trader Joseph Lester Putt as a shop and was later converted into a hotel. An underground passage leading to the nearby parish church is said to exist. (© Crown copyright. Historic England Archive)

Below: Rawdon Colliery Canteen, Bath Yard, Moira
Rawdon was one of five mines in the Moira area, its first shaft being sunk in 1821. A 'troublesome' pit due to frequent flooding and technical problems, it was subject to constant rebuilding and reorganisation. This unusual building was constructed out of concrete between 1930 and 1940. The site is now the National Forest's Conkers Waterside Centre. (Historic England Archive)

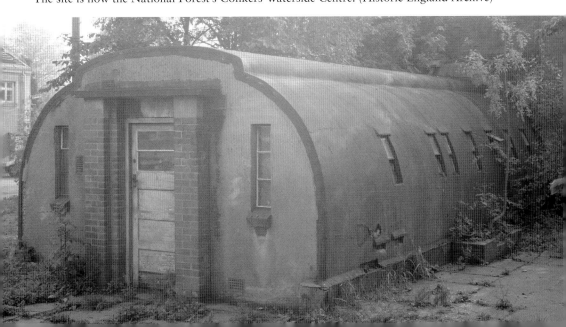

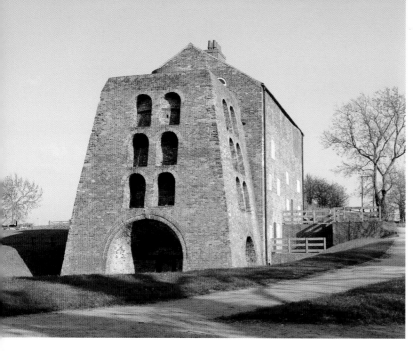

Moira Blast Furnace This is a very well-preserved and very important example of a blast furnace from the formative years of the Industrial Revolution. It was built by the Earl of Moira in 1804 and located near to the Ashby Canal so that coal could be transported to the site from the earl's several pits in the area. (© Historic England Archive)

Below and opposite: The Chapel, Main Street, Tilton on the Hill
It is suggested that this small building, known as 'the Chapel', could be a fragment from a small monastic hospital founded at Tilton on the Hill in the thirteenth century. It was clearly deemed important enough to have survived the later construction of the nearby manor house. It was listed in 1985 and some refurbishment has recently taken place, but its true purpose and role is as yet undetermined. (© Crown copyright. Historic England Archive)

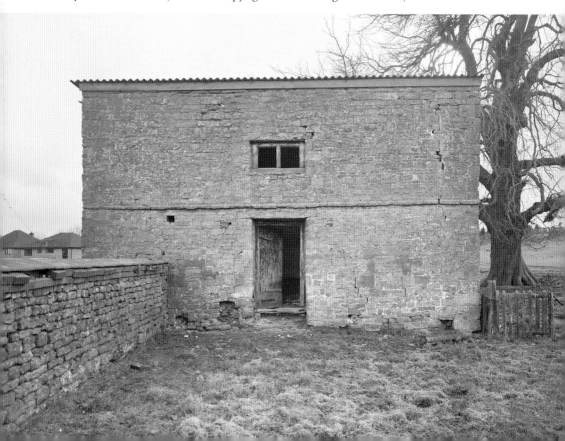

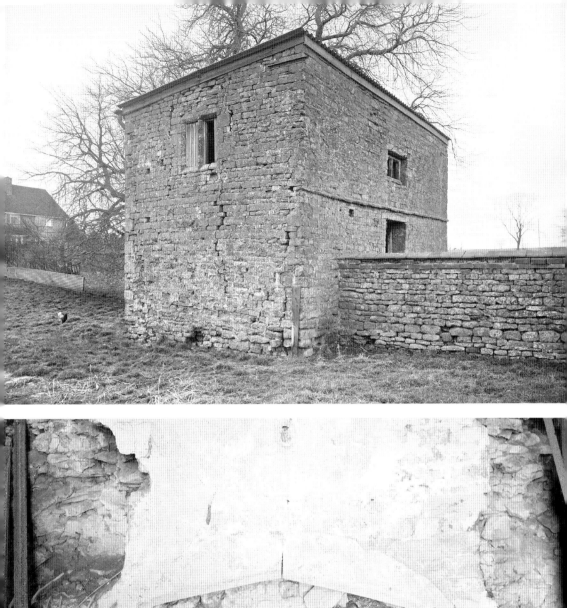

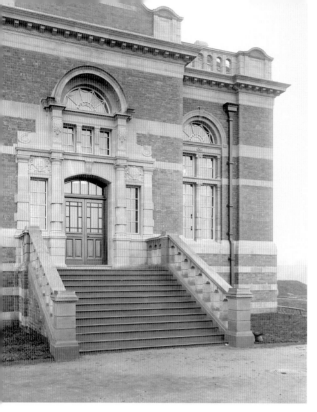

Left, below and opposite:
Swithland Reservoir
These remarkable buildings, some of which are reminiscent of religious architecture, form part of a large complex of structures completed in 1896 to the designs (of great quality and integrity) of Leicester architects Everard and Pick, who also commissioned these photographs. Their necessary inaccessibility has given these buildings protection from vandalism and unsympathetic rebuilding. (Historic England Archive)

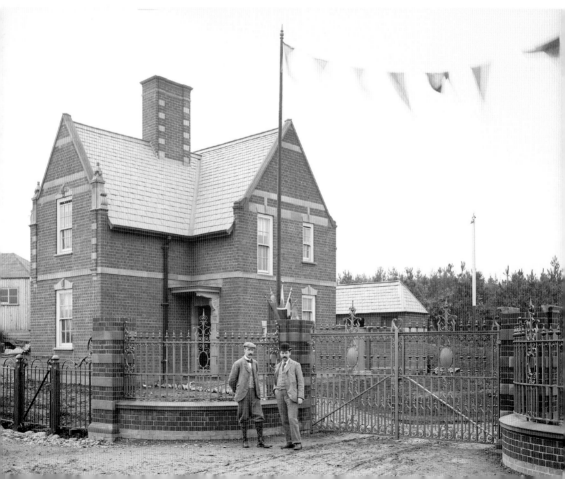

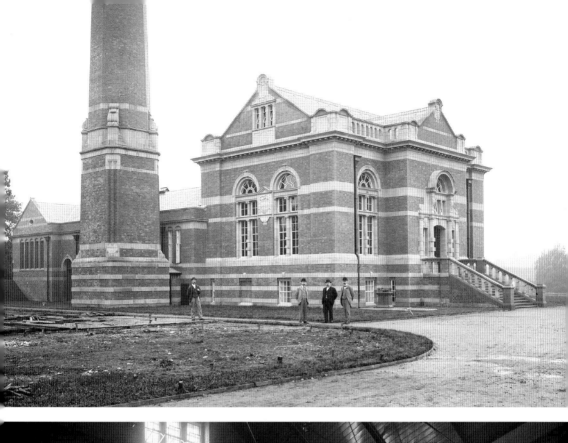
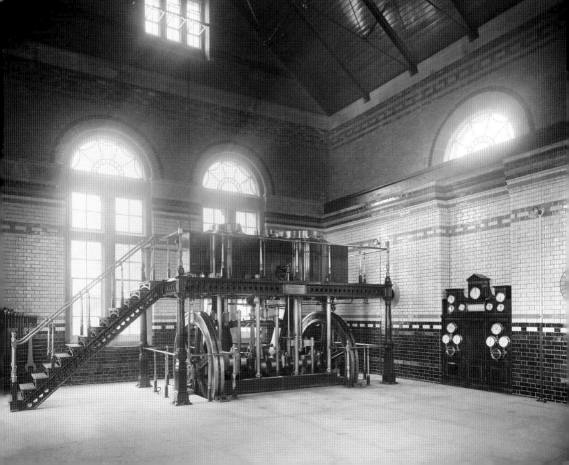

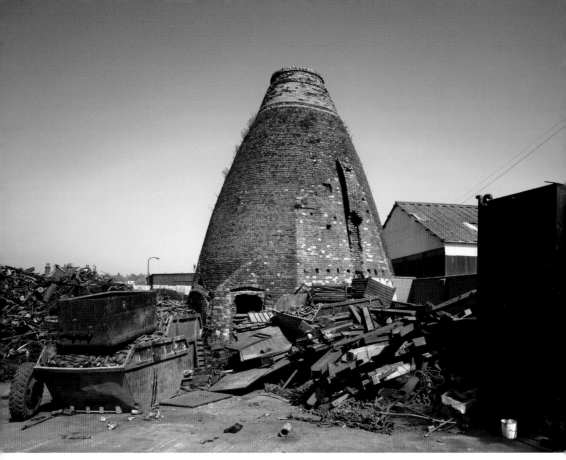

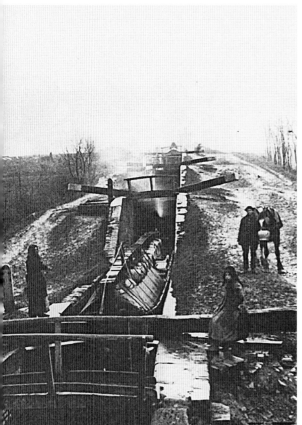

Above: Bottle Kiln, Woodville
This is a very rare artefact and an important part of the industrial heritage of Derbyshire. It is the last surviving bottle or 'beehive' kiln from the former Rawdon Pottery Works, which was once used for firing ceramics. The factory was in the centre of Woodville, but the site is now a scrapyard. (© Crown copyright. Historic England Archive)

Left and opposite: Foxton Locks
Construction of the locks began in 1810 to address a significant change in levels between connecting canals. It took four years to complete the two staircases, each of five locks. An inclined plane was built in 1900 to relieve the congestion caused by the lock flight but it failed commercially and was dismantled in 1926. The entire site is now a major tourist attraction as well as a fully operational part of the canal system. (*Opposite above*: © Historic England Archive)

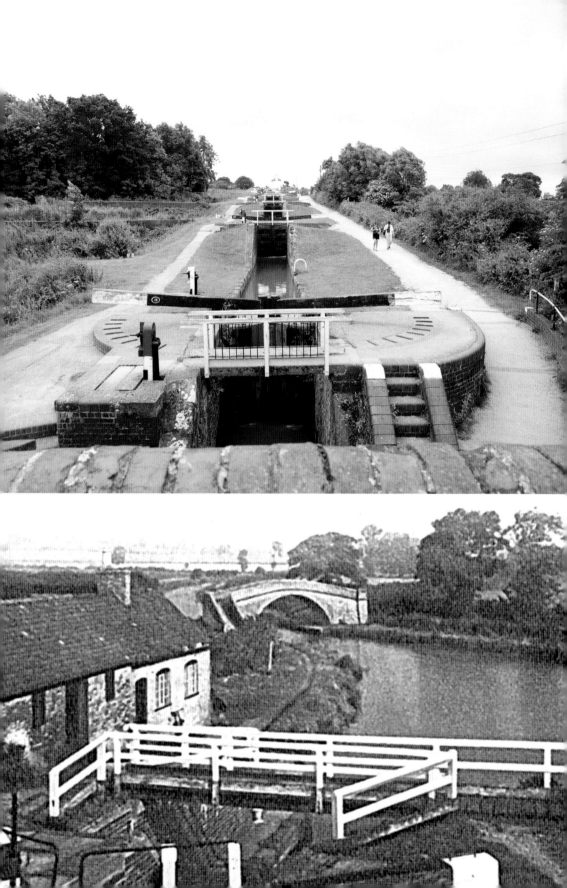

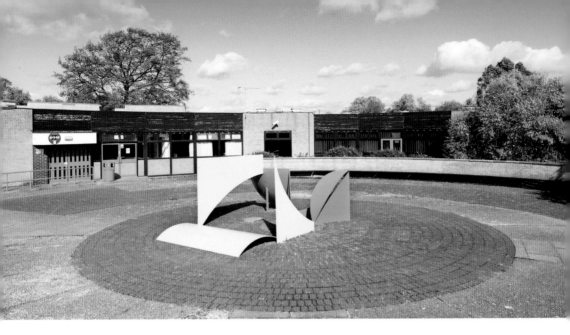

Above: Countesthorpe Community College
The college was built in 1972 and opened as a 'progressive' open school. The sculpture *Dunstable Reel* by Phillip King, formed from mild steel sheets, was at the centre of the school's circular courtyard. It was one of three works bearing the same name, the others being at the Tate Gallery and the National Gallery of Australia. (© Historic England Archive)

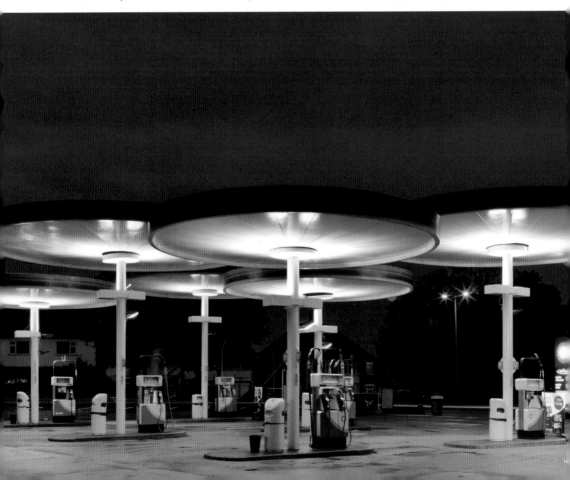

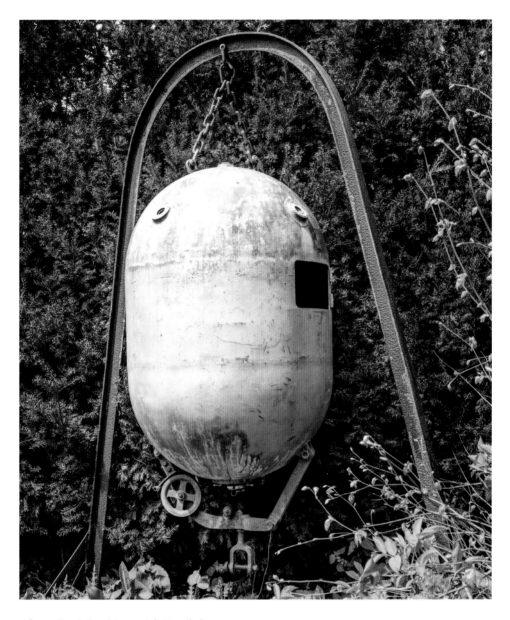

Above: Sea Mine Memorial, Brooksby
An unusual sight in a landlocked country churchyard, this is a sea mine, which is located at St Michael's Church, Brooksby. Earl Beatty, the former Admiral of the Fleet who distinguished himself at the Battle of Jutland and masterminded the country's anti-submarine strategy, lived at Brooksby Hall, and allegedly would at times fire at this mine. (© Historic England Archive)

Opposite below: Red Hill Filling Station, Birstall
In the mid-1960s, the American industrial designer and architect Eliot Noyes was hired by Mobil Oil to redesign and rebrand all its filling stations. In response to the commission, Noyes created the futuristic Pegasus design, which was rolled out across the UK. This building is regarded as a fine example and was justifiably Grade II listed in 2012. (© Historic England Archive)

Country Houses and Estates

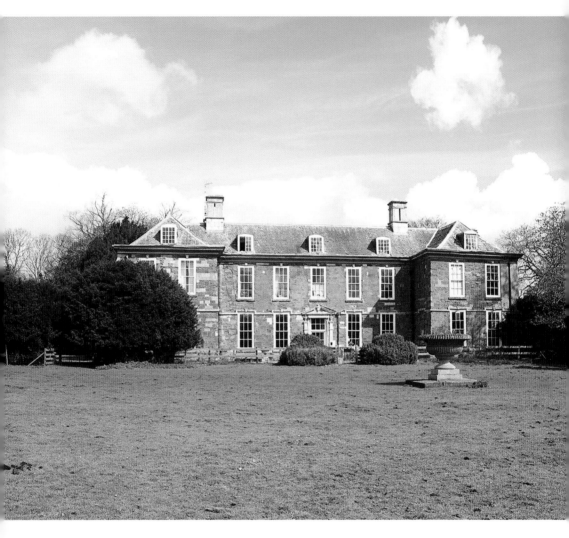

Above: Withcote Hall
The existence of this early eighteenth-century country house has remained relatively unknown because it is a private residence and not situated in a position of visual prominence. Adjacent is the former private chapel, completed in the 1530s, which later served as the parish church. Part of the hall is now ruinous.

Opposite above: The Stable Block, Breedon Hall, Breedon on the Hill
The hall was built at around the time of the Restoration and was constructed from three existing small buildings. It remained the seat of the Curzon family until 1872. During the Second World War, German prisoners were held here in the boiler room. The hall and its outbuildings were later converted into hotel apartments. (© Crown copyright. Historic England Archive)

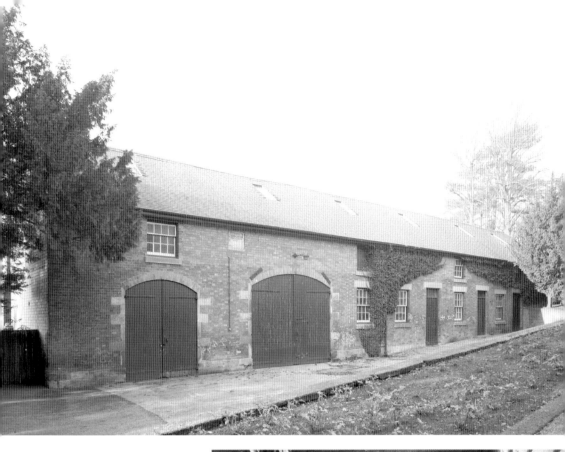

Right and overleaf:
Quorndon House
These images are from a set
taken in 1887 for W. E. B.
(Willie) Farnham of the staircase,
entrance hall and dining room
of Quorndon House, which was
the seat of one branch of the
Farnham family from before the
mid-thirteenth century. It was
formerly known as the Nether
Hall to distinguish it from the
neighbouring Over Hall, which
was also owned by the family.
(Historic England Archive)

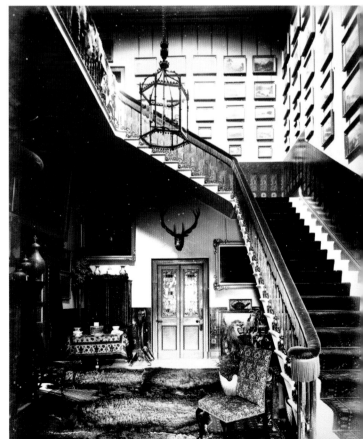

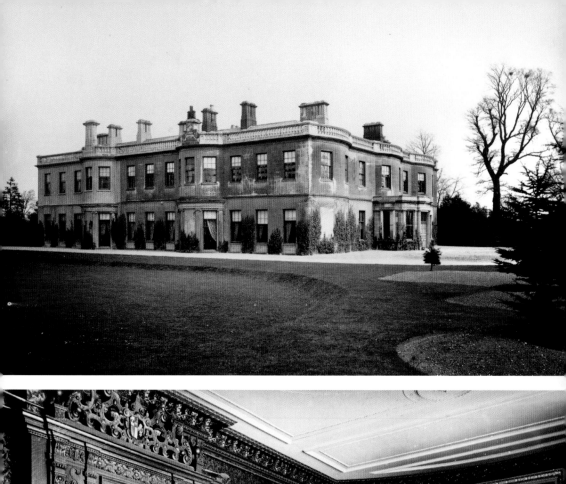
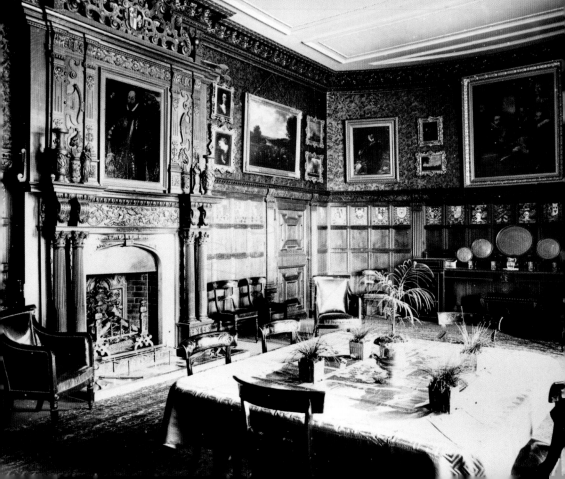

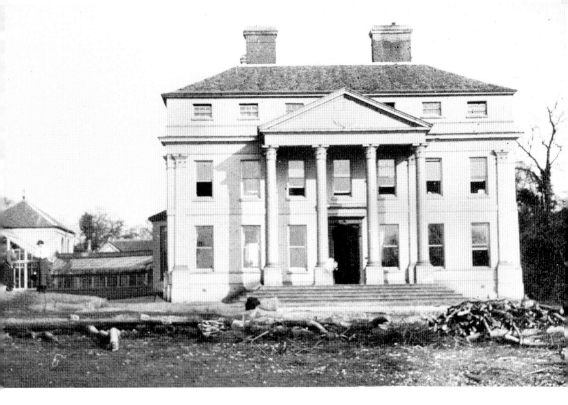

Above: Lindley Hall, Higham on the Hill
William Burton, the author of *The Description of Leicestershire* (1622), was born at Lindley Hall in 1575. This later house was built in 1705 for the wealthy Tory MP Samuel Bracebridge. It was demolished in 1925 after being uninhabited for five years following the death of its last owner, Lieutenant Commander Francis Eyre RN. (Historic England Archive)

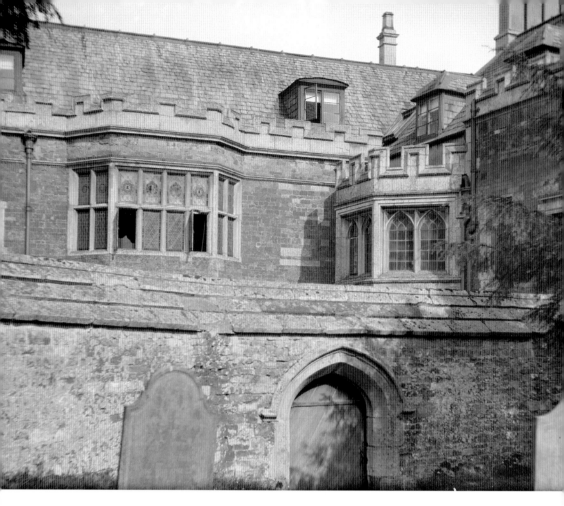

Above and previous below: Skeffington Hall
The south elevation and courtyard of Skeffington Hall viewed from the churchyard of St Thomas à Becket Parish Church. The hall dates from *c.* 1450 with extensions added in *c.* 1530 and the seventeenth century. These photographs, taken in 1906, are by John Alfred Gotch, the noted architect and architectural historian who was born in 1952 and established his practice in the same village. (Historic England Archive)

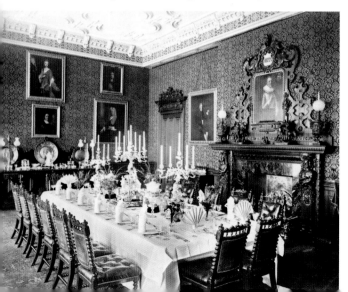

Left and opposite: Beaumanor Hall
Beaumanor Hall was built in 1842–53 by William Railton for W. Perry Herrick. It was constructed on the site of an earlier house, demolished in 1726, also the seat of the Herrick family. The lower photograph shows the dining room with the table laid for a meal. These images are from a set taken for Mrs Perry Herrick. During the Second World War, the hall and grounds served as a Y Centre decoding German coded messages. (Historic England Archive)

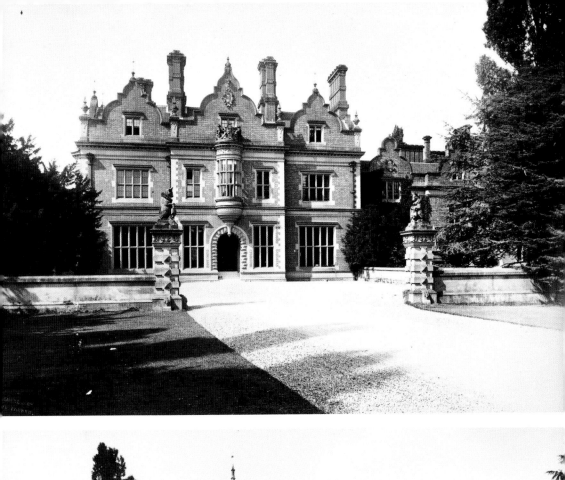

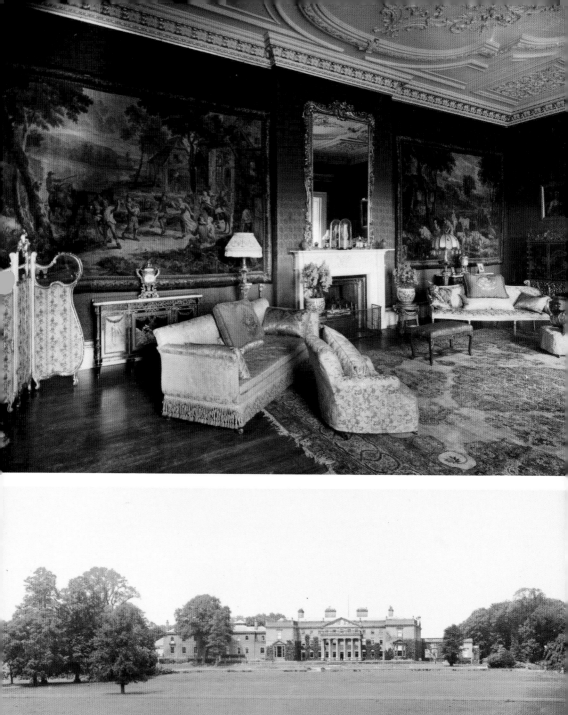

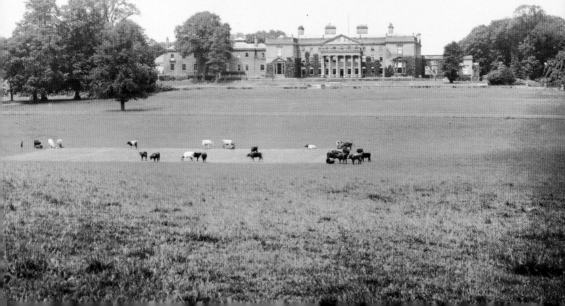

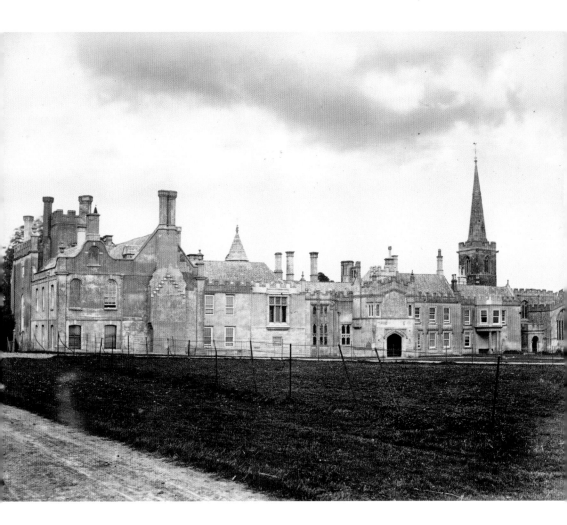

Above: Nevill Holt Hall
A Grade I-listed building dating to before 1300 with many alterations. This photograph probably dates to when the Cunard shipping family owned the estate. Nancy Cunard (1896–1965), writer, publisher and society hostess, was born here. Between 1919 and 1998, the hall housed a preparatory school. Later it was bought and restored by Carphone Warehouse co-founder David Ross. (Historic England Archive)

Opposite: Gopsall Hall, Twycross
The drawing room from an album of the house and estate compiled in the 1920s. The house was demolished in 1952. It was built in around 1750 for Charles Jennens (1700–73), the son of a Birmingham Iron foundry owner, who became a strong patron of the arts. It is said that George Frederick Handel, a friend of Jennens, wrote part of his oratorio *Messiah* in the temple in the grounds. (Historic England Archive)

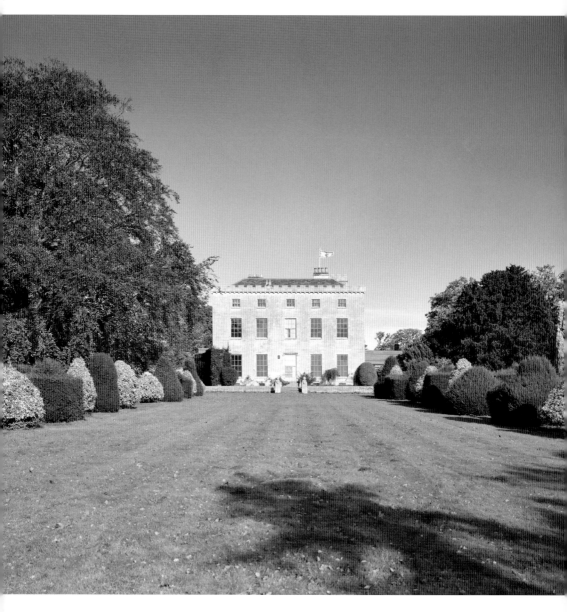

Above and opposite: Langton Hall, West Langton, 1969
The Langton estate was created in the late sixteenth century by Robert Strelley, the Crown's bailiff for the manor of Market Harborough. The hall was rebuilt in the early seventeenth century. The park may be the work of the Revd William Hanbury, the incumbent at nearby Church Langton who was also a professional botanist. Robert Spencer, cousin to Princess Diana, was a recent owner. The hall has since been divided into private residential apartments. (© Crown copyright. Historic England Archive)

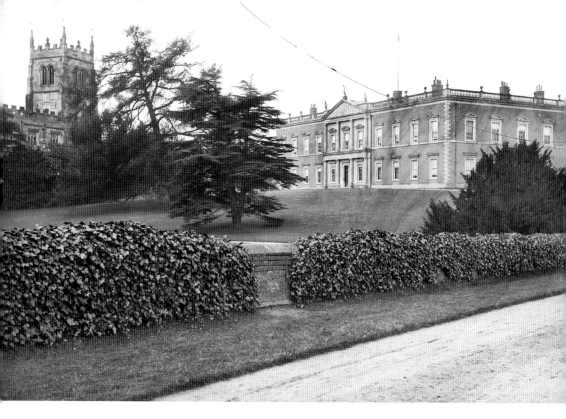

Above: Staunton Harold Hall

Set in a large estate, Staunton Harold Hall was the home of the Earl Ferrers dynasty for over 500 years. More recently, it was used as a Leonard Cheshire Home and now is once again a private family home. This photograph of the hall and Holy Trinity Chapel was commissioned by the London, Midland & Scottish Railway in around 1880. (Historic England Archive)

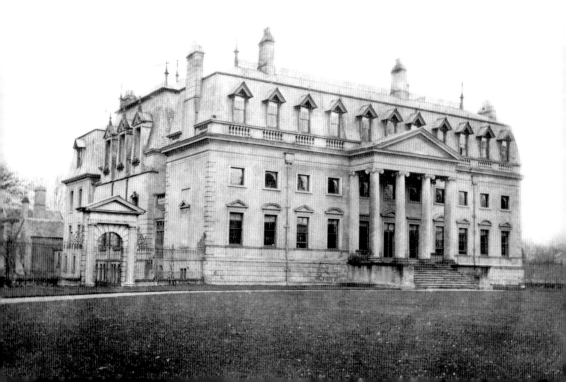

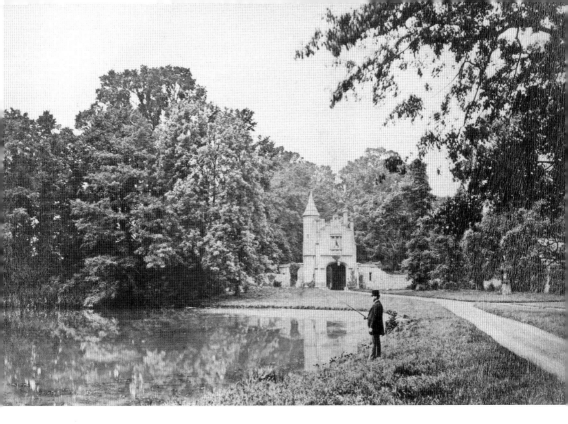

Above, below and opposite below: The Garendon Estate

On the site of an early Cistercian abbey, Garendon Hall and its extensive parkland was developed by Sir Ambrose Phillipps and his heirs. He also built several follies including the Temple of Venus, which have survived. The hall was demolished in 1964, the rubble being used in the construction of the M1 nearby. Pevsner famously described it as 'really rather horrible'. The estate has for some years been encroached by housing development caused by the expansion of Loughborough.

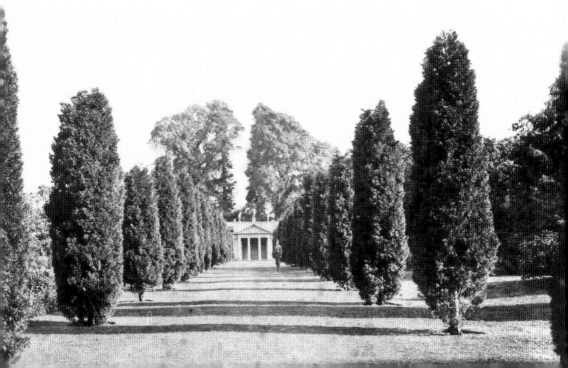

Above and below: Leicester Teacher Training College, Scraptoft
The buildings were constructed between 1957 and 1962 around two courtyards linked by covered walkways in the grounds of Scraptoft Hall and are representative of the design concepts of that time. These photographs by Eric De Mare were taken soon after completion. The college amalgamated with Leicester Polytechnic, later De Montfort University, which closed the campus in 2003. The eighteenth-century hall has been converted to private residential apartments after many years of neglect. (© Crown copyright. Historic England Archive)

About the Author

Stephen Butt is a well-known author of books on local and social history. His research into aspects of Victorian spiritualist beliefs has been published in England and the USA. He was born in Somerset, and worked for a seaside photography businesss in his teens, later writing history articles for a free magazine and the local weekly newspaper.

He gained his first degree from Durham University (BA Psychology) and became a studio manager with the BBC at Broadcasting House and BBC World Service, providing technical support for a variety of speech-based programmes. Stephen was a senior broadcast journalist with the BBC for several years and a member of a local station's management team.

In 2010, he took a sabbatical to work with television historian Michael Wood on his *Story of England* series for BBC2 and BBC4, and later the follow-up series *Great British Story*.

Stephen then decided to become a full-time writer, researcher and freelance local government officer working with parish councils with an interest in neighbourhood planning, community emergency planning and in the preservation of local history and heritage. He is clerk or consultant to five local parish authorities and is a trustee of Kibworth Community Library in Leicestershire.

He was honorary secretary of the Leicestershire Archaeological and Historical Society for ten years and edited their members' magazine (2004–14).

His MA degree is in English Local History (Nottingham), and he holds the Certificate in Local Government Administration.

About the Archive

Many of the images in this volume come from the Historic England Archive, which holds over 12 million photographs, drawings, plans and documents covering England's archaeology, architecture, social and local history.

The photographic collections include prints from the earliest days of photography to today's high-resolution digital images. Subjects range from Neolithic flint mines and medieval churches to art deco cinemas and 1980s shopping centres. The collection is a vivid record both of buildings that are still part of everyday life – places of work, leisure and worship – and those lost long ago, surviving only in fragile prints or glass-plate negatives.

Six million aerial photographs offer a unique and fascinating view of the transformation of England's towns, cities, coast and countryside from 1919 onwards. Highlights include the pioneering photography of Aerofilms, and the comprehensive survey of England captured by the RAF after the Second World War.

Plans, drawings and reports provide further context and reconstruction artworks bring archaeological sites and historic buildings to life.

The collections are housed in a purpose-built environmentally controlled store in Swindon, which provides the best conditions to preserve archive items for future generations to enjoy. You can search our catalogue online, see and buy copies of our images, as well as visiting our public search room by appointment.

Find out more about us at HistoricEngland.org.uk/Photos
email: archive@historicengland.org.uk
tel.: 01793 414600

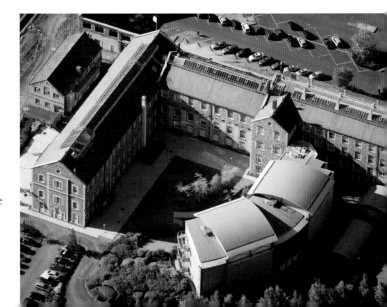

The Historic England offices and archive store in Swindon from the air, 2007.